THE
LARCHMONT
DISASTER
—— OFF ——
BLOCK ISLAND

JOSEPH P. SOARES & JANICE SOARES

THE
History
PRESS

Published by The History Press
Charleston, SC 29403
www.historypress.net

First published 2015

Manufactured in the United States

ISBN 978.1.62619.794.7

Library of Congress Control Number: 2014954846

CONTENTS

Contents

ACKNOWLEDGEMENTS

We gratefully acknowledge and appreciate the help and guidance received in compiling the material and information needed to tell this tragic story. Over the past several years, we have acquired the photographs used for this book from many sources.

We would like to thank the following organizations for their help in providing information for this project: the University of Rhode Island, the Mystic Seaport, the Westerly Public Library and the Island Free Library, Block Island.

As the authors, we strive to bring this maritime disaster to light and make every effort to accurately tell this story as it unfolded. When we first began our preliminary research on this tragedy, we quickly recognized the magnitude of distress this event had on our local communities and the country as a whole. In seeing the historical importance of this tragic event, we began an effort to tell this story.

This would have been nearly impossible to accurately record without the support and contributions of information and guidance from the many local historians and those knowledgeable in New England maritime history who assisted us in our research. We want to give a special thank you to the Steamship Historical Society of America for the good work they do in preserving our maritime history.

We sincerely thank those involved in this project for the generous contributions they made.

INTRODUCTION

The beauty and solitude of New England's coastline leaves those who walk its beaches or view its picturesque shore from the sea with everlasting memories of nature's splendor. However, the impressions held by those who directly or indirectly witnessed the aftermath of the great maritime disaster of the sinking of the steamer *Larchmont* off Watch Hill, Rhode Island, on February 11, 1907, were replaced by the gruesome images of that tragedy. Disasters such as this trigger a range of feelings in those touched by such an event. Many, at first, refuse to accept that such an unpleasant incident could happen; this resistance or disbelief soon changes to acceptance, and the mind then begins to ask why. The sinking of the *Larchmont* was thoroughly investigated after the incident and official determination rendered. Many, however, thought justice for the victims and their families wasn't pursued. The *Larchmont*, first named *Cumberland*, was a side-wheeled steamer furnishing transportation from New York, New York, to Providence, Rhode Island, and other excursions in the early 1900. It, like many other steamers that plied the waters of Long Island Sound, were a great convenience, offering comfort and speed compared to overland travel. The *Larchmont*, however, quickly gained a reputation for being a hard-luck ship after several unfortunate incidents. A collision in Boston Harbor in July 1902 that caused the steamer to sink in shallow water, to the dismay of the captain and crew, was one of many unfortunate incidents that befell the ship. On another occasion, a fire broke out aboard the ship while it was in Long Island Sound. Over 200 terrified passengers onboard had been safely put ashore after the flames had

been extinguished. A few years after the fire, the *Larchmont* was in an accident with a schooner off Stratford, Connecticut, near Bridgeport. During that same period, it ran aground in Narragansett Bay and then again just off Prudence Island. Off North Brothers Island, in 1905, a fire caused by faulty wiring broke out aboard the ship. The final episode was a collision with the schooner *Harry Knowlton* off Watch Hill, which claimed the lives of well over 143 people; many believe the number of lives lost to be much higher. This disaster, one of the worst in New England's maritime history, could, as many of the other unfortunate mishaps of the *Larchmont*, have been avoided. However, as maritime folklore goes, a hard-luck ship is destined for a watery grave, with or without man's assistance. This book—an accumulation of facts reported in news accounts of the day and official records—is a broad view of this unfortunate tragedy.

1
NIGHT OF TERROR

Astrong northwesterly wind blew down through the eastern passage of Narragansett Bay on the night of February 11, 1907. The passenger steamer *Larchmont*, loaded with passengers and freight, left the wharf at Providence, Rhode Island, bound for New York, New York. Setting off down the Providence River and Narragansett Bay, it rounded Point Judith and proceeded through Block Island Sound, where the *Larchmont* encountered the full effects of a strong gale and large waves. The captain of the *Larchmont*, George W. McVay—occasionally written "McVey"—who had been in the pilothouse as the ship left the wharf and sailed out to sea, left to make his rounds, leaving control of the ship in the hands of his officers. After his inspection of the ship, the captain returned to the pilothouse and spoke with his officers and then went to his cabin. Within a short time, several blasts of a steam whistle sounded, startling Captain McVay.

The captain hurriedly made his way to the pilothouse. As he looked eastward, he saw a schooner moving along under a strong wind. Several more blasts from the *Larchmont*'s steam whistle were sounded. In the pilothouse, the pilot and quartermaster spun the wheel hard to port in a frantic effort to avoid the collision. As the *Larchmont* responded slowly to the pilot's efforts, the schooner *Harry Knowlton* suddenly rose upward and headed straight for the steamer. It seemed to be traveling at the speed of the gale that filled its sails. Before another blast from the steam whistle could be sounded, the schooner *Harry Knowlton* crashed violently into the port side of the *Larchmont*, eating its way into half the breadth of the large steamer.

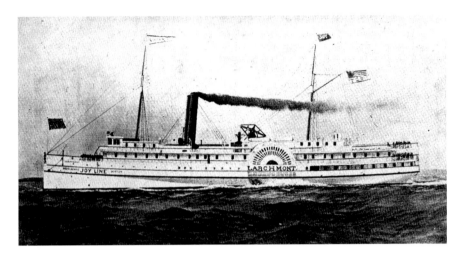

The steamer *Larchmont* of the Joy Line, out at sea.

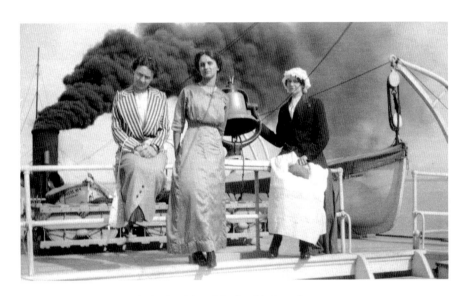

Passengers on the upper deck of a ship, while the ship is underway.

The velocity of the impact from the schooner tore through the vitals of the *Larchmont* and then the schooner sat helpless within the innards of the crippled steamer. Acting like a plug in a bottle, the schooner held tight, keeping out the ocean. The raging seas rocked the two vessels, and after a short time, the violent seas separated the two vessels. When the schooner *Harry Knowlton* became free from its entanglement, it slid away, and the

raging ocean rushed into the gigantic hole in the *Larchmont* that was left by the impact. With no watertight compartments that could be closed, the steamer's fate was sealed. Ocean water filled the cargo hold of the steamer within minutes. The rushing water sounded like a freight train as it made its way toward the boiler room. As the water hit the boiler's red-hot skin, enormous clouds of steam rose up.

The panic-stricken passengers on deck watched in amazement as the events unfolded. Many of the passengers who were resting in their cabins were thrown from their bunks during the collision. Numerous passengers came streaming out from their cabins and onto the decks, reacting out of fear, believing a fire had broken out onboard the ship. Very few had taken the time to properly cloth themselves during the turmoil.

The zero-degree temperature seemed to go unnoticed by many at first, but it soon became evident that the frigid weather threatened the passengers' safety. Many of them found it impossible to return to their rooms, which were now flooded, making their belongings unusable. The ship, now floundering, was sinking rapidly. The dire situation eroded the professionalism of the crew aboard the *Larchmont*. Preparations to lower the lifeboats and rafts began. The extreme cold numbed the hands and feet of the passengers and crew alike, turning noses and ears white with a bitter frost.

As the lifeboats and rafts were loaded haphazardly—many being only partially filled as they were pushed away from the ship—chaos began to reign as the shrieks of the drowning filled the air.

Those who considered themselves lucky to find refuge in the lifeboats soon understood their situation and the fact that the cruel pain of the violent weather that they would endure had just begun. As the small lifeboats bobbed along in the high seas, spray from the ocean rose up and covered them with each wave. Before long, a thin coating of ice enveloped the boats, leaving those partially clothed in mortal pain.

The nearest point of land was Fisher's Point, to the west of where the steamer went down. All the struggling crafts headed in that direction. The men at the oars, many half dead, strained against the unrelenting gale. Before long, the crafts became separated, and each faced its own ordeal. The first word of the disaster came to Block Island at 6:00 a.m., brought by a young man named Fred Hiergesell, who survived the collision and departed the sinking ship in a lifeboat. The boat he was in capsized just offshore of Block Island. Once in the water, the young man swam frantically to shore. Suffering physically and mentally from the ordeal, he made his way to the North Lighthouse near where he came ashore. At the lighthouse, he

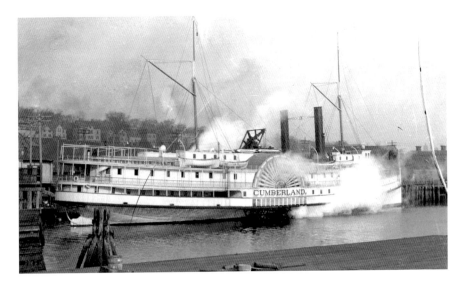

The *Cumberland* while under steam power.

pounded on the door, half crazed. Elam Littlefield, the lighthouse keeper, was awoken, and he quickly dressed. Opening the door, Littlefield found a young man in a pitiful condition. As the young man entered, he collapsed, muttering, "More coming, more coming." The lighthouse keeper woke others, and they began tending to the young man, now half-conscious, while he continued muttering, "More coming."

A chilling scene occurred aboard the captain's lifeboat that night. As the men aboard struggled at the oars, which had frozen because of the cold temperature, one man found the situation unbearable and pulled out a knife from his coat pocket and plunged it into his throat. The man then fell from his seat to the floor of the boat while all looked on in disbelief.

Once the lifeboat floated ashore at Block Island, assistance was given to those aboard, none of whom could walk because of their badly frozen feet. All the survivors were carried from the lifeboat to shelter. Those who assisted with the rescue soon realized the severity of the ordeal for those in the lifeboats. The lifeless body of the man who could not endure the situation was gently removed from the lifeboat and brought inland.

At another location on Block Island, a surfman from the United States Life-Saving Service, while on beach patrol, noticed a surreal image emerging from the surf. The visibility that morning was poor, and a heavy mist covered the ocean. As the patrolman made his way around the northwest side of Block Island, a man caked in ice staggered out of the surf and onto the

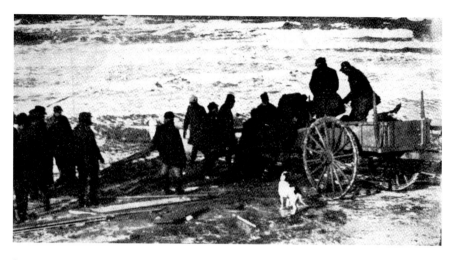

Retrieving bodies along the beach on Block Island.

beach. The surfman brought the man to the lifesaving station for aid. A short time from when the man walked ashore, a lifeboat full of frozen bodies drifted out from the fog and onto the beach. Word spread of the situation, and within hours, the majority of the population of the island came to the shore to help. From the direction of the disaster, bodies began floating ashore one by one. Those who gathered to assist began the daylong task of hauling the unfortunate ashore from the icy surf, many of who encased in inches of ice.

Many of the bodies had their arms raised as if they were swimming, retaining their forms as they became frozen in the act by the severe weather. Sympathetic tears from the islanders fell on the faces of those being gently placed on the wagons for the journey inland. The few that came ashore alive were well cared for and given the best medical attention the island could offer.

The lifesaving stations at New Shoreham and Sandy Point were used as temporary morgues. The frozen bodies retrieved from the ocean were laid out on the floors. Many of those on the island who assisted in the rescue would never forget the gruesome scene of the many bodies with their twisted limbs frozen in place. The lifesaving stations were also used as hospitals. Carts and beds were set up in the sleeping and living rooms of the stations.

The pitiful condition of those being treated at the makeshift hospital tore at the hearts of those rendering aid. Many of the survivors suffered from severe frostbite. Some of them needed fingers or hands amputated. Compounding the physical ailments of the survivors were the emotional

Transporting survivors from the New Shoreham Life-Saving Station.

injuries from that horrible night. Many of those being cared for could not sleep with the images of the terror from the prior night running through their minds. At the hospital, cries of anguish filled the air that first night.

Days after the disaster, the steamer *Kentucky* of the Joy Line was dispatched to Block Island to pick up the survivors as well as the bodies of the unfortunate who died in the accident. Relatives of the deceased gathered in Providence to await the arrival of the funeral ship *Kentucky*, which carried the bodies of their loved ones. The *Kentucky* arrived much later in Providence than planned, due to the difficulties in getting the bodies aboard ship at Block Island.

The bodies had to be transported five miles by wagon to where the *Kentucky* was located and then loaded aboard. One of the survivors wouldn't board the *Kentucky* for the trip to the mainland. Sadie Golub, traumatized by the events of that dreadful night, refused to go aboard the *Kentucky* or any other ship, afraid that another incident might happen once out to sea. Needing proper medical treatment for potential pneumonia and frostbite, she was finally persuaded to make the trip. The *Kentucky* made additional trips to the island for the purpose of bringing back bodies that were found later.

The schooner *Harry Knowlton*, after backing away from the collision, quickly began taking on water. Captain Frank T. Haley and his crew of six quickly began pumping out the ship in an attempt to keep it afloat. The crew managed to sail the schooner toward the shore, but before long, all efforts to save the ship were abandoned.

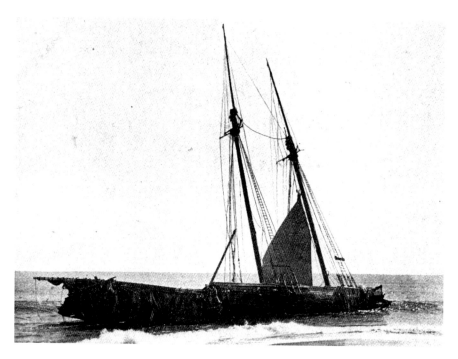

Remains of the schooner *Harry Knowlton* off Watch Hill, Rhode Island.

The crew then boarded the lifeboat, pushed away from the ship and attempted to row ashore. The men, enduring the extreme cold and heavy surf, struggled to row their lifeboat toward the beach. While floundering just off the beach, a surfman from the Quonochontaug Life-Saving Station spotted them and came to their aid. Once on the beach, the crew of the schooner walked about three miles to the Quonochontaug Life-Saving Station where they were given food and shelter. The men of the *Harry Knowlton* were very fortunate; had it not been for the crew's proficient seamanship, their fate might have been similar to that of those onboard the *Larchmont*.

FEBRUARY 12, 1907

As the residents of Block Island and many living along the shores from Westerly to Providence, Rhode Island, awoke to the news of a tragedy that had occurred while they slept, concern quickly spread. They were some of the first to hear the news of the tragedy that befell the steamship *Larchmont*.

Details of the unbelievable events that took place just off shore the night prior trickled in. As the day wore on, it became evident that there had been a great loss of life. Much of the news of the collision spread neighbor to neighbor, and many hearing of the tragedy had trouble digesting some of what they were hearing. As the details were put in print, those skeptics became aware of the facts.

News accounts began with the basic details of the incident: that the *Larchmont* left the wharf at Providence, Rhode Island, around 7:00 p.m. on February 11, 1907, bound for New York, New York, with an estimated one hundred passengers. The vessel was also half loaded with a cargo of mixed freight.

The beginning of the voyage was routine as the *Larchmont* navigated its way down the Providence River, mastered by George W. McVay. Once the *Larchmont* passed Sabin's Point, the control of the vessel was given to the first pilot John L. Anson; this was an established custom. This procedure was in full compliance with the provisions governing the navigation of steam vessels. Soon after Captain McVay gave command to the first pilot, he began a routine inspection of his ship and its freight. From the pilothouse, he proceeded to the salon deck and then to the main deck.

As a tradition, he would stop and talk to members of the crew. Captain McVay would then make his way to the engine room, also located on the main deck. After talking with the engineer, the captain would move aft to the quarterdeck to where the salon watchmen were located. He would stop at the purser's office to speak with the steward. On that day, Captain McVay left the purser's office at 10:40 p.m. and headed for his room, which adjoined the pilothouse on the upper deck.

On entering the pilothouse, Captain McVay conversed with first pilot John Anson. At this time, Montauk Point and Watch Hill Light could be seen from the pilothouse of the ship. Captain McVay then left the pilothouse for his room. First pilot John L. Anson was fully in charge of the vessel at this point. A short time thereafter, red and green lights from an oncoming vessel were noticed in the distance.

The *Larchmont* was three miles away from Watch Hill Light. As the two vessels approached each other, Anson began maneuvering the *Larchmont* based on the navigation lights of the oncoming ship. This fruitless effort did more to contribute to the collision than avoid it. Within moments, the large schooner *Harry Knowlton* and the steamer *Larchmont* collided.

Just prior to the collision, Captain McVay, who had left the pilothouse only some five to seven minutes prior, jumped up from his desk where he was looking over some bills given to him in Providence. A series of short

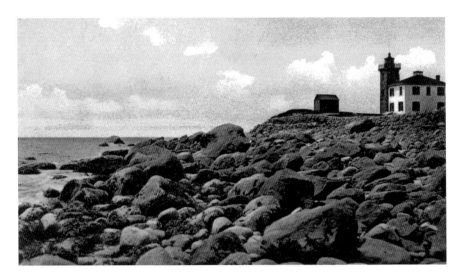

The Watch Hill Light in Watch Hill, Rhode Island.

blasts from the steam whistle of the *Larchmont* filled the air. After putting on his coat, vest and cap, the captain ran into the pilothouse. Captain McVay noted that the *Larchmont*'s helm was hard aport and the quartermaster was straining at the wheel, and he thought this unusual. The captain then noted Pilot Anson at the pilothouse window with field glasses, staring out the window. The captain looked out the window to see a large schooner bearing down and coming broadside of the *Larchmont*. Before the captain could do anything to correct the situation, the two ships collided.

Upon the violent collision, the stricken steamer stopped abruptly. Captain McVay staggered from the pilothouse to survey the damage. The *Harry Knowlton*, at an estimated speed of eleven knots, came to rest some fifty feet forward of the *Larchmont*'s port paddle box. Captain McVay ran to the speaking tube located in the pilothouse, seeking information on the condition below.

Ringing the engine room several times with no reply, the captain commanded quartermaster James Staples and the second pilot George Wyman below to bring back a damage report, determining the condition of the engines and whether the pumps could be started to contend with the seawater that was now flooding the ship. Within minutes, Quartermaster Staples returned but had no luck in gaining information from below. Soon after, Pilot Wyman informed the captain that the chief engineer encouraged the beaching of the *Larchmont* as soon as possible.

Lifeboats lined up on the starboard side of the ship.

The captain ordered his officers to their stations. Captain McVay made his way to the starboard side to lifeboat number one. The vessel was tilting heavily to starboard and had swung around southward. Captain McVay stated to several of the crew that they must get the lifeboats equipped on the leeward side of the ship in an attempt to save as many passengers as possible. As the captain's boat and others on that side of the ship were being readied, Captain McVay assisted the chief engineer on the port side of the ship in an effort to swing the boats into the water. Captain McVay returned to his boat and ordered it lowered as he called out to others to do the same.

Once in the water, those in the lifeboats quickly realized the difficulties they were about to face in dealing with the below-zero temperatures, forty-mile-an-hour winds blowing from the northwest and the vicious sea splashing up a cold spray of water. As the small boats slowly moved away from the sinking ship, many noted the horrible scene. Those who lived conveyed their nightmarish story to the world.

That first day, one of the most shocking news reports regarding the collision was the number of souls lost. The exact number of passengers onboard that night was unclear. The first numbers reported to the world were roughly two hundred perished and only eight survivors. This was shocking and left many

demanding to know how such a tragedy could happen. As the first newspaper accounts would state, this was one of the worst collisions involving a steamer. Preliminary information on how such a collision could have happened was incomplete. Much of the information released by newspapers that first day was believed to be fact, but days later, many other details released would put in question what really happened that horrible night.

As to the fate of the schooner *Harry Knowlton*, first accounts reported that it drifted eastward after the collision and came ashore just west of the breach way at Quonochontaug Beach.

It should be noted that in later news reports and testimony, Captain McVay declared that the navigation lights of the *Larchmont* were burning brightly. This issue of the *Larchmont*'s navigation lights would be brought into question in later investigations.

FEBRUARY 13, 1907

As the next day unfolded, the disaster off Watch Hill had become clearer. New estimates of the loss of life were reduced to 150 souls lost and 19 known survivors. Many new details concerning the collision and damage that crippled the *Larchmont* and caused it to sink so quickly were reported. The high winds that night had filled the sails of the schooner *Harry Knowlton*, contributing to the severity of the impact of the schooner on the steamer. The schooner was reported to have crashed more than halfway through the *Larchmont*, causing severe damage and dooming the ship.

Immediately after the *Larchmont* absorbed the enormous impact, the *Harry Knowlton* stayed lodged deep in the bowels of the steamer. The two vessels remained interlocked for several minutes. As the sea's large waves pounded the two vessels, water began rushing into the hull of the large steamer. As the two big vessels began to lose their tight embrace, the schooner slowly dislodged itself and floated off. Now with a gaping hole in its side, the large steamer's fate was sealed. With each wave, large amounts of water filled its hull. The steamer was reported to have no watertight compartments, which would have slowed the onrush of water. The water soon reached the boiler room. As the water hit the boilers, large plumes of steam rose up. The large amounts of steam created chaos among the passengers, many of who had no idea what was happening.

After the collision, the passengers, many of whom were previously sleeping or settled comfortably within their heated rooms, became curious. They

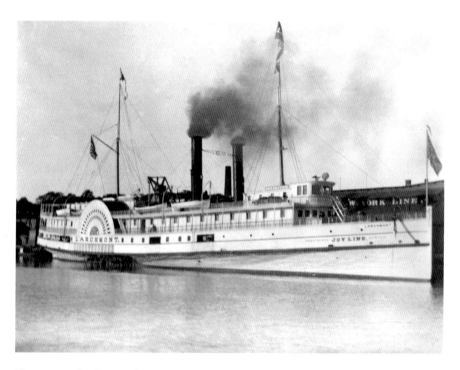

The steamer *Larchmont* tied up at the wharf.

ventured out of their rooms and onto the frigid deck. The freezing weather and high winds turned some back to their rooms for proper clothing. Those without proper protection from the elements would soon find the fast-moving events overtaking them, giving them no time to retrieve proper clothing. For those passengers who remained in their rooms, it became apparent to them how bad the situation was once the floor began to slant to one side.

Within a few minutes, many found themselves rushing from their rooms in search of answers. Many of the passengers began frantically asking the crew what they should do. The pitiful conditions left those that came from their rooms only dressed in nightgowns chilled to the bone. Once Captain McVay gave the order to ready all lifeboats and rafts into the water, a rush to the boats by the confused passengers ensued.

Before many of the passengers could reach their lifeboats, Captain McVay's boat, the largest of the lifeboats, pushed off from the steamer as the ocean rose up and covered the deck of the ship.

Captain Frank T. Haley of the schooner *Harry Knowlton* made a statement to officials investigating the collision. The account of that night was printed in the newspaper the *Westerly Sun*:

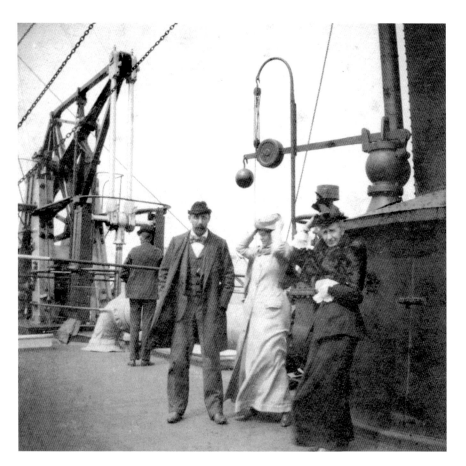

Passengers standing on the upper deck of a ship.

My full name is Frank T. Haley. I am 58 years of age and live at Everett, Mass, where I have a wife and 15 children. I have followed the sea for a livelihood ever since I was able to get about a deck. I have been master for several years and have had experience in the coastal trade. This is the first real accident that I have ever had. I don't ever want to have another one. If a man has never gone through a ship wreck I hope he never will. It is an experience that once gone through no man will ever forget. The Harry Knowlton *is as smart a craft as any that is engaged in the coasting trade. We loaded coal at South Amboy, New Jersey[,] and left there with 400 tons in our hold on Thursday, casting off about seven o'clock in the morning. We had a good run until we arrived at City Island, when we became icebound and were unable to get away until about 10:30 o'clock Monday morning,*

when we got underway and proceeded up the sound. We had just ran out of the race when I started to go into my cabin. Leaving the deck in charge of the mate, Borgeson who was the bow watchmen and Johnson was at the wheel. The night was a beautiful one the stars shone clear and bright and we could see a long distance across the water. We had every sail set and as the wind was fresh and favorable everything was drawing full. When I entered my cabin, we were going a little east by north, and I was congratulating myself that everything was prosperous for a quick and safe trip.

I had been in the cabin but a few minutes when I heard Mr. Govand ask the bow watch if all the lights were right.

This struck me at the time as being a peculiar question, for the mate to ask of the bowman, especially on such a clear night. The more I thought of it the more mystified I became. I had not begun to disrobe, so, buttoning up my reefer, I stepped out on deck and looked over the bow. There several hundred feet off the starboard bow, we saw distinctly the light of a big steamer. Borgeson, who was at the bow, answered the mate, everything is all right, sir.

I started towards the bow, seeing that the steamer was holding to her course, and was pointed to go to the starboard of us, I turned and told the mate to have the helmsman keep her straight on her course. We continued to howl along with a good big bone in our teeth. I had just turned to look at the steamer again as I thought that even on the coarse [sic] on which I first discovered her it would take her pretty close to me. When I was surprised to see her veer sharply to port and cut directly across my path.

I knew instinctively that a collision was inevitable it was to late however for me to do a thing, and even if I had decided to do so. The impact came to quickly that my course would not have been changed. With a crash that made the Knowlton reel and bury her nose under the water, the prow of the big steamer crushed into her starboard bow just abaft of the bowsprit.

At the same time, the bowsprit of the schooner became entangled amid the stanchions and wood work of the steamer and with a rending of woodwork and tearing that I shall never forget as long as I live.

After the schooner *Harry Knowlton* became free of the *Larchmont*, a bewildered captain and crew began to assess the damage to their ship. A few members of the crew who were below deck when the crash occurred came running up, visibly shaken.

Captain Haley began giving orders in a valiant effort to save his vessel. As the captain assessed the damage, he quickly realized that the hull of his ship

Passengers sightseeing on the deck of a ship.

was smashed and water was rushing in. The captain ordered crew members to operate the pumps, and then he ordered that the vessel head toward land. At about 10:30 p.m., the captain reassessed the condition of his vessel and the rising water pouring into the hull, estimated to be close to seven feet at

that time. The captain ordered some of the crew to make ready the lifeboat. After feeling several severe shudders from the ship and seeing large waves breaking over the deck, the captain ordered the crew into the lifeboat.

Noting they were about a mile from shore, the captain ordered the men to the oars and then to push off. As a few of the crew struggled to row in the direction of land, the high seas bobbed the boat up and down like a cork. Within a short time, a lookout spotted a red light coming from shore. The crew doubled their efforts and rowed toward the light. They soon realized what they were seeing was the red light from a torch being held by a patrolman from the lifesaving station. Several in the boat began yelling for assistance but, because of the harsh weather conditions, went unnoticed.

After a few frantic moments of struggling with the oars in the choppy surf, substantial headway was made. They made another effort to be noticed. They then noticed the red torch of the patrolman had changed direction and was moving toward their boat. It was at that time the crew of the *Harry Knowlton* knew their condition was much improved.

As the crew disembarked the little craft and made their situation known to the patrolman of the Quonochontaug Life-Saving Station, the anxiety of

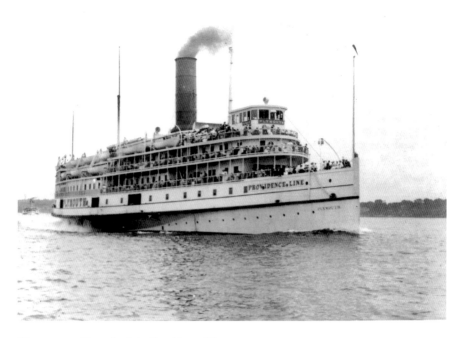

The steamer *Plymouth* of the Providence Line.

their ordeal was lessened. The crew spent a restless night at the lifesaving station consoling one another.

The next afternoon, some of the crew and members from the lifesaving service made their way down the beach to where the *Harry Knowlton* had washed up during the night. The schooner sat broadside, with its starboard side toward the beach. The crew of the *Knowlton* was sad to see the proud ship in such a condition. The tide was quite low, and it took the men little effort to make their way onto the water-soaked deck. Once onboard, the crew noticed kitchenware, food, cans and other items scattered about the deck. The crew was first bewildered because these items were not from the *Harry Knowlton*. On further examination, they concluded that the schooner must have ripped into the steward's department, and the items must have been deposited onto the deck of the schooner during the collision. As men looked over the items, a small brown book was recovered. To their surprise, it was an account book from the steamer *Larchmont*. This was the first piece of evidence the crew had as to the identity of the other vessel involved in the collision. The crew, now bewildered and thinking of the fate of the steamer, went about retrieving some of their own items. As their search revealed, the sea had claimed most of their personal possessions.

FEBRUARY 14, 1907

With the daylight came a renewed search for remains from the steamship *Larchmont*. A new number of those who lost their lives was reported at 138, but many believed the number was much higher. Captain William E. Withey, an official from the United States Steamboat Inspection Service, located in New London, Connecticut, was sent to Westerly, Rhode Island, on the morning of February 13 to collect information and evidence about the collision.

An official investigation had begun. After stopping in Westerly, he went on to the Quonochontaug Life-Saving Station to take testimony from captain Frank T. Haley of the schooner *Harry Knowlton*. Captain Haley's account of what transpired that night was vital to the investigation. After Captain Haley gave his statement to Captain Withey, Captain Haley praised patrolman Grover Eldredge of the Quonochontaug Life-Saving Station for his timely appearance and the aid given to him and his crew on that unforgettable night. He then stated that all of his crew

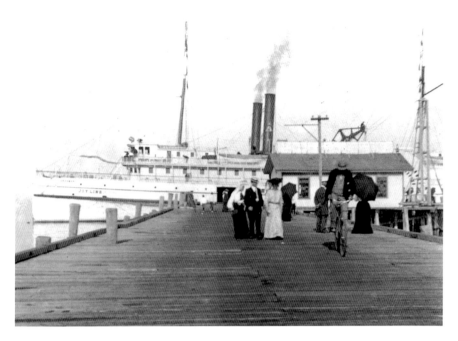

The steamer *Larchmont* tied up at the pier while passengers board and depart the ship.

acknowledged that if it were not for the patrolman, the outcome of their rescue would have been different.

In an account from Patrolman Eldredge, while on his patrol on the night of the collision between the steamer *Larchmont* and the schooner *Harry Knowlton*, he saw an abandoned vessel just off the beach. As he headed in its direction, he noticed a small craft with several men aboard in distress just offshore.

He quickly proceeded into the surf, pulled the small boat ashore and gave what assistance he could. Once the crew was out of the boat, Patrolman Eldredge provided them a warm drink from his flask. The men were then brought to the lifesaving station, where they warmed themselves in front of the station's stove.

As the day went on, a report stated that seventy-one bodies were recovered in the early morning hours. Many boats continued their search offshore. Off Block Island, several local fishermen aided in the search. They reported calm seas. The many bodies that had washed ashore on Block Island left vivid images in the minds of those who assisted and rendered aid to the survivors.

At the Watch Hill and Quonochontaug Life-Saving Stations, additional patrols were carried out along the shore for bodies. Owing to a shift in the wind, they believed that anything that was not washed ashore at Block Island

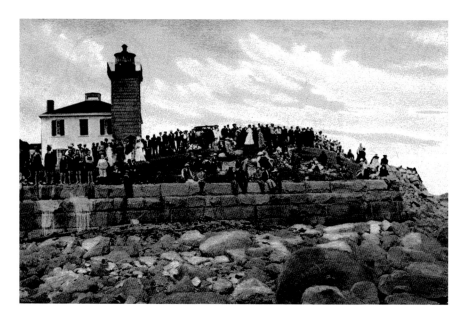

Light House Point in Watch Hill, Rhode Island. People are gathered to watch a shipwreck come ashore.

or retrieved near the collision might wash ashore on the mainland. The strong gale north and west had carried the aftermath of the collision toward Block Island. Many at the station knew that the current would rock and shift the *Larchmont* where it sat on the ocean floor, and this movement might release additional bodies from the ship and wash them ashore at any time. They knew they would have to be vigilant in their patrols.

During the day, near Watch Hill, freight from the stricken steamer began to wash ashore. Several cases of elastic were removed from the beach. As new information about the collision was reported, disturbing statements and charges of cowardice against the captain and crew of the *Larchmont* came out. A young Brooklyn man would recall his ordeal.

Fred Hiergesell

Eighteen-year-old Fred Hiergesell—one of the few passengers onboard the steamer *Larchmont* to survive the ordeal that fateful night—was traveling alone, en route to his home in Brooklyn, New York. Hiergesell gave testimony to officials on March 7, 1907, regarding the collision and his effort to save himself before

A passenger posing for a photo on the deck of a ship.

the *Larchmont* sank. He stated that he was asleep in his berth at the time of the collision. After being awoken by a loud noise, he quickly dressed and headed out onto the deck of the ship. There he saw several people running about.

Because of the darkness, he had trouble seeing at first. As he walked about, he noticed a large hole in the side of the ship. Within minutes, several other passengers were on deck. He saw large plumes of steam and sensed that the steamer was in real peril. He noted several of the crew made statements to other passengers that nothing was the matter, and there was no fear that the ship was going to sink.

At that point, he had seen many of the passengers return to their staterooms. He then retrieved a life preserver and made his way to the lifeboats. The ship began to lurch to one side, and many on deck began to panic. When officials investigating the collision asked him later if he had seen Captain McVay during this ordeal, Hiergesell stated that he saw Captain McVay, along with several of his crew, in the very first lifeboat to depart the sinking ship. In regards to his own safety, Hiergesell stated that he made several unsuccessful attempts to secure a place in one of the lifeboats. His plan was to jump into one before it pushed off, but before he could, the lifeboat capsized. He found it futile to keep trying because of the many panic-stricken passengers battling for a spot in the departing lifeboats.

He headed to the other side of the ship. He noted single women—many partially clothed and some only dressed in nightgowns—shrieking for help. Several of the women were in total hysteria, but Hiergesell didn't see any aid being given. This vivid scene of young women half-frozen and begging for help would forever haunt him. Hiergesell's declaration of the actions of Captain McVay would bring many to seek answers and justice for the victims.

Hiergesell was able to board the last lifeboat just as the steamer sank. There were five others in the lifeboat beside himself. Those onboard began to row, but the ocean was too rough, so they drifted. At 6:00 a.m., the boat capsized just off Block Island. He said he began to swim just as he touched the water and was able to make it onto the beach. When asked if the others on the boat were saved, he answered that they all drowned and he was the only one saved out of that boat.

James E. Staples

James E. Staples, quartermaster aboard the *Larchmont* that night, survived the disaster. Born in Penobscot, Maine, and twenty-eight years of age at the

time, Staples made a startling claim that he believed the loss of life on that night was 332, making it the worst maritime disaster of its time.

Staples would give testimony to officials on February 16, 1907. He stated he had only been quartermaster aboard the *Larchmont* for two weeks. He said on that night, the pilot of the *Larchmont* was John Anson and it was Anson who gave him the course to steer the ship that night.

Once the *Larchmont* reached open water, the visibility was good (with no fog, vapor or snow), and the wind blew from the northeast. As the ship rounded Point Judith, he was ordered to steer west quarter south. He told officials the pilothouse windows were open, and he could see the bow lookout at his station. It was shortly after this that he had noticed the lights of a schooner off in the distance. He could also see Watch Hill Light at that time.

The bow watchman also reported seeing a ship far off. When asked by an official how far off the schooner was when he first noticed it and how long after that the collision take place, Staples replied that the schooner was about a half mile away, and from the time the schooner was first sighted until the collision was about two minutes. Staples told officials that prior to the collision, he was ordered to steer to port in an effort to distance them from the oncoming schooner.

As the schooner got closer, he was ordered to turn the wheel to port more. Staples was asked if the ship steered hard; he replied it did not that night. He then told officials that he was holding onto the wheel hard to port when the schooner struck the ship. Captain McVay came into the pilothouse just before the collision. Just after the collision, the captain sent him below to see what condition the engines were in. Because of the thick steam, he could not get very far. He returned to the pilothouse and reported to the captain but was so choked up that he could not speak. The captain asked him several times for a report, and he was finally able to get the captain to understand that he could not bring back a damage report.

Staples was later asked about his departure from the sinking ship. He said that after the captain gave the order to man the lifeboats, he proceeded to the starboard side of the ship. His boat station was number one, which was also the captain's boat. When he reached the bow, there were no passengers around. There was a lot of steam in the air, making visibility difficult. The boat he was stationed to was lowered into the water and then he climbed over the side of the ship into it.

Captain McVay was already seated in the boat. Staples was asked if the captain appeared excited at all at that time. Staples replied, "Not in the least. The captain ordered the lifeboat to head for the other side of the steamer in

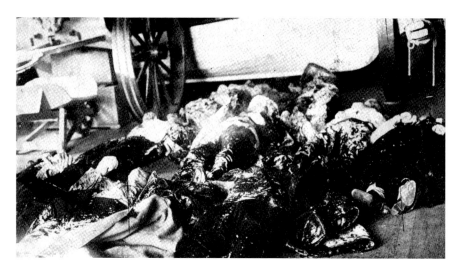

Bodies that washed ashore at New Shoreham and were taken to the lifesaving station in Block Island.

an attempt to pick up passengers. We heard a lot of screaming coming from the ship. The gale was heavy and our attempts to get to the other side failed, and then we began to drift." As they floated off, the last thing he saw of the ship was the bow and pilothouse, and he estimated that within three minutes of that the steamer sank out of sight. Staples continued:

> *After the steamer disappeared, we did not hear or see anything. The captain then said that we should try to make Block Island. We attempted to row the boat, but were unsuccessful. The lifeboat drifted sideways in the direction of Block Island without our control. The conditions were difficult aboard with a cold ocean spray constantly blowing over us. All we could do is sit there and take it.*
>
> *Everyone seemed to have become immobilized by the weather. In the bottom of the boat water accumulated from the waves crashing over the side and becoming six inches deep. No one bailed the water from the boat or steered due to our condition. We became very weak and covered in ice. At about 6:30 a.m., we floated ashore at the north end of Block Island, a few hundred yards from the life-saving station.*

FEBRUARY 15, 1907

The morning began with the unsettling news that more bodies had floated ashore at Block Island and a passenger from the *Larchmont* who survived the sinking had passed away at the hospital. Samuel Lacomb from Manchester, New Hampshire, who had came ashore in one of the lifeboats the day after the sinking, had suffered severely from the elements, but those attending to him hoped he would recover.

The number reported to have survived stood at 18, with 54 dead and 87 missing. Many, however, believe the number onboard the *Larchmont* that night was much greater than the number of 159 reported in many newspapers across the country. The ordeal continued to bring much pain to the residents of Block Island.

Many of those aiding in the rescue believed that a reprieve of the gruesome sight of bodies being transported about the island was forthcoming. Owing to the change in the wind, many believed there would be no more bodies washed ashore. On the mainland, no bodies from the *Larchmont* had washed ashore between Watch Hill and Quonochontaug. There was some expectation that a change in the direction of the wind would wash bodies from the disaster ashore, but officials had stated that a recent change in wind direction to the northwest would carry any floating bodies out to sea. Since the disaster, the lifesavers at Watch Hill, Rhode Island, had increased patrols along their stretch of beach. The bodies that were recovered at Block Island were taken to the morgue on the mainland for identification.

Sadie Golub

Sadie Golub, a nineteen-year-old dressmaker from Boston, Massachusetts, was traveling alone aboard the steamer *Larchmont* the night of the disaster. She was found ten hours after the collision atop a piece of wreckage. Golub was unconscious when members of the crew of the fishing schooner *Elsie* plucked her from the water. She was taken to Block Island and then to the home of George Milliken, where she regained consciousness and was very eager to tell her story. She began by stating that while in the midst of the disaster, she had pleaded with Captain McVay and purser Oscar Young to let her aboard their lifeboat. To her dismay, they had pushed her away. She claimed their boat had pushed off with only six aboard.

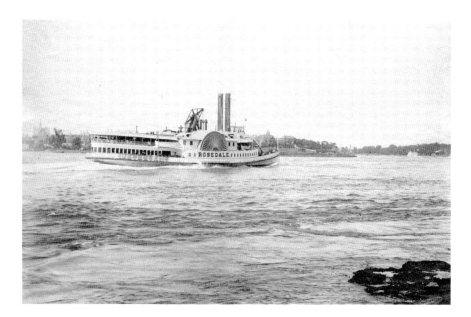

The steamer *Rosedale* while underway.

Golub was born in Russia and arrived in the United States in 1905. She had booked a stateroom aboard the *Larchmont* and had been reading a book in her berth at the time of the collision. Her room was well heated, and she stated that she only needed to wear a petticoat and waistcoat in it. She told officials investigating the collision that she had been in her room for about three hours when she felt a shudder that was severe enough to compel her to jump from her berth and dress.

Running from her room and onto the deck, she noted panic among the others who were gathering around the lifeboats. She ran to the lifeboats. She begged members of the crew for help and for them to take her aboard their boat. After ignoring her pleas, they pushed off and floated away. Distraught, she then proceeded to the upper deck where she stood, holding on to the rail as the steamer sank. She recalled standing on that part of the deck with several others. She estimated it took about half an hour for the water to reach her.

As the steamer sank, that part of the deck detached from the ship and floated off with her and several others aboard. She estimated that there were twelve others on that deck at the time. She recalled holding on to a ladder that was frozen to the deck. This helped her remain aboard the wreckage as it bobbed up and down among the waves. At dawn, while still aboard the

wreckage, she lost consciousness and did not know the fate of the others or how she was rescued. Owing to the frigid cold that night, she had suffered severe frostbite to her hands and feet. She later would give an official account of what she remembered on the night of the collision to the United States Steamboat Inspection Service.

FEBRUARY 17, 1907

As the day began, reports came in that the schooner *Harry Knowlton* sat one mile east of Weekapaug, Rhode Island, and had begun to be torn apart by the large waves. The rocking back and forth from waves and tides had separated the ship amidships, and its contents had started to spill out. On its deck was a mass of tangled rope and timber. The ship's sails, still in place, were tattered and torn, and the flapping of the canvas could be heard up and down the beach.

From the beginning of this disaster, many communities within the state of Rhode Island offered what assistance they could. Unsettling accounts of those who survived that night began to weigh heavily on those who followed the situation. One community in particular mourned deeply for the families and friends who had lost loved ones on that night.

The horror of the accounts being reported had brought out strong feelings, and many began demanding answers. Many residents of Providence, Rhode Island, felt that the safety for passengers was not the Joy Line's first priority, and the company's reputation was questionable. As the finger-pointing played out over the next few months, one fact in particular seemed evident: many in the city had expected such a tragedy to happen. Many believed that the Joy Line's standards for passenger safety were inadequate.

As the official investigation continued, questions were raised about the exact number of passengers aboard the steamship *Larchmont* that night. Only those passengers who had booked a stateroom would have been recorded, and the official passenger list had been lost at sea. Many conflicting estimates of the number onboard had been reported on the first day. Over the next several days, officials estimated the probable number of those onboard at over 150.

Curious people from the surrounding communities made the trip to the shore to view the wreckage of the schooner *Harry Knowlton*. Many of the sightseers would walk the stretch of beach between Watch Hill and

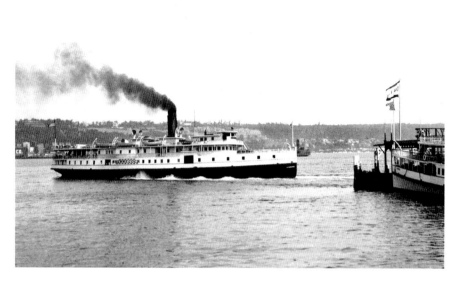

The steamer *Shinnecock.*

Quonochontaug, Rhode Island, in search of a souvenir that would bring them solace and serve as a reminder of the terrible disaster. Harris Taylor, who made a trip to the beach from Ashaway, Rhode Island, had retrieved from the surf an oak table and seven chairs that came from the *Larchmont.* A writing desk, believed to belong to the purser on the *Larchmont,* was also found on the beach by William Ecclestone.

Work began to locate the remains of the *Larchmont.* Officials noted that the steamer might pose a threat to other ships. A ship from the Revenue Cutter Service was dispatched and began searching for the sunken steamer. The mast from the *Larchmont* was located offshore and towed to New London, Connecticut. No other wreckage was located that day. Steamboat traffic had reported no signs of the steamer that protruded above the waterline. Officials believed it impossible to raise the steamer if found and that, if it was found and determined to be a navigation hazard, dynamite should be used to break it up.

The salvage company T.A. Scott of New London, Connecticut, which purchased the salvage rights of the *Harry Knowlton,* dispatched the tugboat *Harriet* to begin work on unloading some of the coal cargo in the hull of the schooner.

A few days after the collision, captain George W. McVay sent a letter to the United States Steamboat Inspection Service. He stated that on the

A Joy Steamship Company meal ticket.

night of the disaster and prior to the collision, he had made his rounds as he normally did, went to the pilothouse and conversed with those there and then left, leaving the control of the ship to first pilot John L. Anson. In his letter, he commented that, at that point, everything was shipshape. He proceeded to his room to attend to some paperwork.

After hearing several loud, rapid blasts from the *Larchmont*'s steam whistle, he quickly made his way to the pilothouse. There, he noted a schooner on the port side, very close and heading headlong in the direction of the *Larchmont*. In a moment, the schooner had struck the *Larchmont*. Knowing that the collision was severe, Captain McVay called down to the engine room for a damage report. Getting no response, he ordered the second pilot and quartermaster to proceed below and get a damage report.

Captain McVay stated the ship had become enveloped in steam and he noticed everyone around him becoming panicked. He ordered the crew to their stations, admitting that at that point, he believed the vessel was severely damaged and could sink. He rang the ship's bell, which was a signal to start the engines, but he did not receive a response. He walked to the deck and ordered the lifeboats cleared away. He noted the *Larchmont* had a severe starboard list. He ordered his lifeboat to be loaded and noted no passengers in that area at the time. His lifeboat was then lowered into the water, and he said the only people he saw were those who had gotten into his boat: himself; Oscar Young, the purser; James E. Staples, the quartermaster; Louis

McFarland, a waiter; James Varn, a fireman; and two others whose names he could not recall.

The lifeboat Captain McVay was in was cast off and made its way around the bow of the sinking steamer to the port side in an effort to see if any others could be saved. Because of the high winds and heavy seas, they were unable to help anyone. He emphasized that his lifeboat had stayed in the area, and they made every effort to locate anyone needing help but found no one to pick up before the *Larchmont* sank out of sight. He also stressed that it was bitterly cold and difficult to maneuver. The lifeboat began to drift.

Estimating the collision between the *Larchmont* and schooner occurred at about 10:50 p.m., he stated that after drifting for several hours, his lifeboat came ashore at Block Island at about 6:30 a.m. on February 12. In his statement, Captain McVay said that on arrival at Block Island, those in his boat were in terrible condition. He then restated that prior to the collision, the *Larchmont* was in shipshape condition.

Captain McVay would later give testimony under oath to officials investigating the collision between the steamer *Larchmont* and schooner *Harry Knowlton*.

FEBRUARY 18, 1907

The day's news began with an official report being made public of Captain McVay's version of what happened the night of the collision. He gave his account of what happened to the United States Steamboat Inspection Service. The account caused a lot debate in regard to how the crew had performed their duties that night.

In Providence, Rhode Island, several pastors made responsibility the topic of their Sunday lectures. They felt they could not be silent about this subject because of the fact that many news accounts about the *Larchmont* disaster were being reported and the fact that a young woman had begged for help only to be pushed away. Some asserted that any good man who takes on the responsibility to keep others safe is bound under God to do so and for that person to do less is a sin.

Furthermore, others condemned the Joy Line, owners of the *Larchmont*, for not taking proper safety precautions. To put the poor travelers in unsafe boats with an irresponsible crew was inexcusable. The question was asked aloud whether the pilot of the *Larchmont* might have miscalculated,

The steamer *Clermont* tied up during winter months.

deliberately trying to get as close as possible to the schooner *Harry Knowlton* without them colliding.

In Nantucket, Rhode Island, a terrible reminder of that dreadful night washed ashore and made many speculate the fate of the so-called lucky ones who had successfully secured a spot in one of the lifeboats to escape from the fast-sinking ship. This reminder came in with the tide in the form of a lifeboat that was barely recognizable. It had been badly crushed and what bewildered many was the fact that the lifeboat showed signs that it had been occupied by some who escaped from the sinking ship. If so, it left the questions of how the boat became so badly damaged and what had been the fate of those onboard. It was estimated the boat had floated some fifty miles or more with the help of the wind and currents.

No other wreckage had washed ashore along the coast of Rhode Island that day. At Watch Hill, an official order was given to keep on the lookout for wreckage that might come ashore due to a change in the wind.

A false alarm came in from a local man who had been in the vicinity of Watch Hill. The man had become alarmed when he spotted two bodies lying on the beach. He believed they were victims of the *Larchmont* and went for help. When he returned to the spot with official from the lifesaving station, they took a close look and discovered the two bodies lying on the beach were not the victims of the *Larchmont* disaster but were the victims of whiskey. The two were lying in the wet sand, very much alive and well.

FEBRUARY 24, 1907

The day began with the search for the location of the *Larchmont*, but because of inclement weather, the search had to be put on hold. The lighthouse tender, Cactus, had been vigorously searching the area where it was reported that a fishing trawler had been caught on the *Larchmont*, but the search was postponed for several hours until the weather changed for the better.

The schooner *Harry Knowlton* had been sitting on the beach and was reported to be breaking up because of the high waves rocking it side to side. The mast of the schooner had been detached and removed from the vessel. The canvas sails had been torn to pieces by the high winds, and the large quantity of rope aboard the schooner had been removed.

Officials from the Providence Board of Government Inspectors took testimony from two important witnesses, Mathis Libert and John Tolen. Both men were part of the crew and were aboard the lifeboat containing Captain McVay. The two men could not speak English well but still gave detailed accounts of that night. They made it evident that the intensity of the collision that night was such a shock that it left them dazed and confused.

The steamer *General Lincoln* running close to shore.

Mathis Libert

Mathis Libert, a crew member aboard the steamer *Larchmont* who survived the sinking, gave testimony on February 23, 1907, in Providence, Rhode Island. Libert stated that he was twenty-eight years old and his position aboard the ship was a fireman. His job was to keep the boilers supplied with coal. When asked by officials about what he'd seen that night, Libert stated that when he heard the collision, he ran to the upper deck of the ship and toward the forward end. There, he saw many people running about and noticed a lot of steam.

When asked if he had seen any officers or the captain, he replied no. Libert said he noted the lifeboat he was stationed at was being lowered into the water. He jumped into it and noticed the captain already seated. They pushed away from the sinking ship and when they were thirty to forty yards away, the steamer went under the water. When Libert was asked what assistance they rendered to others, he replied he could not do anything for them because the visibility was bad and the wind and waves made maneuvering the lifeboat difficult. He then said the lifeboat drifted most of the night before coming ashore at Block Island.

Richard Hall

Thirty-three-year-old Richard Hall, a waiter aboard the *Larchmont*, had survived by staying afloat atop a piece of wreckage. He told officials that after he felt the shaking of the ship and heard the steam whistles, he knew that a collision took place. He said he immediately went below deck to wake up anyone unaware of the situation. Before he made it very far, those below came running up, many half dressed and asking what had happened. He then proceeded to the staterooms and began pounding on doors, warning passengers of the situation. As he went from room to room, he came across a man who was intoxicated. He gave the man a life preserver and told him to put it on. Hall told investigators that a steward from the ship came over to him and told him to get those life preservers out of sight, claiming everything was all right.

After the steward left, Hall began handing them out again. After a few minutes, he went below, where he ran across a woman. He said she seemed confused so he began to plead with her to go above to the main deck. She would not move, so he proceeded to go upstairs to the saloon.

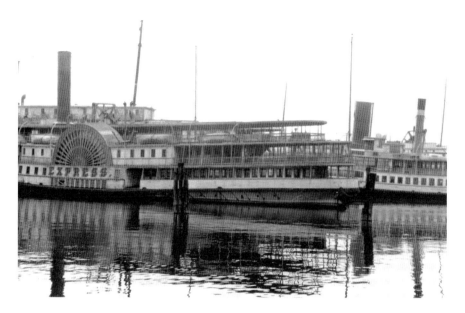

The steamer *Express* tied up during winter months.

There, the lights of the steamer began to dim. They soon went out, and many of the passengers around him began to howl and pray. He proceeded to his lifeboat station, where he found no one. He went to the hurricane deck, and as he went along, several others followed. When he reached the hurricane deck, he said the ship lurched and began to sink. The hurricane deck that he and sixteen others were standing on broke loose from the ship and began to float off.

The heavy waves rocked the deck up and down during the night. Those on the deck held on for their lives as it became partially submerged. Hall told officials that there were sixteen people on the deck when it detached. Out of the sixteen, only five survived the ordeal. He said that during the night, the heavy waves would pound down on them, forcing all of them on their hands and knees.

Drenched with cold water from the relentless waves, many began suffering from hypothermia. Several times during the night, a large wave would hit, sweeping someone on the deck into the churning ocean. The deck floated in the direction of Block Island. At around 5:30 a.m., the deck drifted close to Block Island and those onboard who survived the night could clearly see the houses on the island. Hall stated that they hooted and howled in an attempt to attract attention but were unsuccessful.

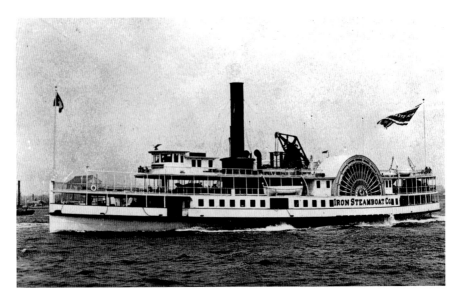

A steamer of the Iron Steamboat Company.

As waves pushed them closer to shore, those aboard contemplated jumping into the surf in an attempt to make it onto the beach. Because of the frigid water and their feeble condition, they decided to remain on the deck in hopes of being rescued. The deck drifted past the island. At about 11:30 a.m., they had drifted about twenty miles when they spotted a schooner heading toward them. As the schooner came closer, it turned and lowered two small boats into the water.

The small boats came alongside the deck, rescuing the five who remained alive. The small boats returned to the schooner, and the ship headed to Block Island. Once at the island, the five had to be hoisted ashore because none of them were able to walk on their own.

Harris Feldman

Forty-year-old Harris Feldman was a passenger aboard the *Larchmont* on the night of the disaster. Feldman told investigators that he was asleep at the time of the collision. Woken by the crash, he jumped to his feet and then shook his wife, who was also asleep, and told her to get dressed. He left his stateroom and noticed a lot of steam and many people running about.

A young lady posing for photo next to sign stating Steerage Passengers Not Allowed Aloft.

Making his way onto the deck, he noticed a large three-masted schooner penetrating into the steamer. He ran back to his room and told his wife of the accident. He waited while she got dressed, and then they both left their stateroom and made their way up to the hurricane deck. Feldman told officials that he saw the mast break off and the steamer's chimney crash onto the deck. Within a few minutes on the hurricane deck, he heard a loud crash and said it seemed like the ship broke apart.

During this time, he noticed a lifeboat being lowered into the water. He grabbed his wife, and they made their way to this lifeboat. He took his wife and placed her in the boat. The boat was full so he told her to save herself and that he would try to save himself by finding a piece of wood to stay afloat on. As the lifeboat pushed off, Mrs. Feldman jumped overboard and climbed back onto the sinking ship. She told her husband she did not want to save herself without him. Within minutes, the deck they were on broke free from the ship and began to float off. He told officials that there were sixteen others on the deck, but by the time they were rescued the next day, only he and four others survived. He said that they were spotted by the schooner *Elsie* and then rescued from the piece of wreckage and brought to Block Island.

George W. McVay

George W. McVay gave testimony to officials on March 20, 1907, in New London, Connecticut. In his testimony, he stated that he was born in Bangor, Maine, on August 26, 1880, and had worked on many vessels since he was a young man. He had eleven years of experience and had worked as a watchman, quartermaster, pilot and master for the Joy Line. He had held a master's license, as well as a first-class pilot license, for passenger steamers since he was twenty-one years of age. Captain McVay was asked about the steamship *Larchmont*, its age and dimensions.

Captain McVay told officials that the *Larchmont* was built in 1885 and was 250 feet in length. The ship was built in Bath, Maine, weighing in at 1,605 tons. When asked what condition was the ship in on February 11, 1907, Captain McVay replied that it was in perfect condition, as far as the law required. Captain McVay was then asked about the cargo onboard the *Larchmont* on the night of the collision. He said that there was merchandise of all kinds—iron pipe, machinery, cases of soap, oysters and bales and cases of cotton—with much of the cargo being stored on the main deck. Captain McVay said the weight of the cargo carried that night was half of what his ship could carry.

When asked for a description of the ship's superstructure, Captain McVay said it consisted of staterooms and a main saloon from the main deck up. He said there were also staterooms on the hurricane deck and to the front of that was a pilothouse and officers' quarters. Officials asked how often fire drills were carried out by the crew of the *Larchmont*. He replied that fire drills were carried out once a week in Providence, Rhode Island. He told officials that a drill would consist of the ringing of the fog bell for five seconds and pulling the main gong four times; this would warn of a fire, and the crew would go to their stations.

Each officer on the ship had been assigned a lifeboat with four to five crew members to assist him. The boat was raised, swung out and readied to be lowered into the water. Captain McVay told officials that crew members were changed regularly, and he was not certain that all of the crew members onboard the night of the collision were present at the last lifeboat drill held.

Officials asked Captain McVay many questions regarding the day-to-day operations onboard the ship, as well as questions regarding the Joy Line company. A question regarding the wages paid to the officers of the *Larchmont* had raised concern. Officials asked Captain McVay to compare the wages of other steamship lines that navigated between New York, New York; Providence, Rhode Island; and Fall River, Massachusetts, to that of the Joy

A section of the steamer *Larchmont*'s hurricane deck that washed ashore at Sandy Point.

Line. Captain McVay replied that the wages paid by the Joy Line were quite far below average. He was then asked if he thought the wages were adequate to attract competent people to those positions. Captain McVay replied, "I do not believe it did, as a rule."

Officials then asked a series of questions regarding officers that were onboard the *Larchmont* on the night of the collision—in particular about first pilot John L. Anson. When asked about Anson, Captain McVay said he was twenty-nine years old and had been employed by the Joy Line for nearly four years. Prior to his move to the position of first pilot, he was quartermaster on the *Larchmont* for a short time. Captain McVay said he was an upright young man, being a very quiet fellow who lived onboard the steamer.

Captain McVay was asked if he ever at any time found Anson asleep on watch. Captain McVay replied no. He was asked if he ever had concerns with Anson. Captain McVay replied, "I never have found him lacking." The captain was then asked many general questions about the night of the collision. His responses were limited but to the point.

Captain McVay was then asked to state in full just what he saw take place—the sensation he experienced, the extent of the damage done and the first move he made to save his ship and passengers after the collision with the schooner *Harry Knowlton*. He said:

First the boat stopped immediately; the engines stopped immediately; I jumped from the pilot house to look at the place she had made; I then jumped

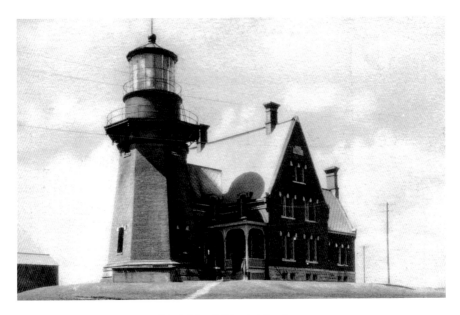

The South East Lighthouse in Block Island, Rhode Island.

out of the pilot house toward the rail and looked over, then came back to the pilot house and rang the bell calling the engineer to the speaking tube. I asked—I got an answer from the engineer, just simply "Hello." Asked what the conditions were below, got no answer; rang again, got that "hello" again; asked for the conditions, got no answer; then sent Quartermaster Staples, who was nearby, below.

About that time the second pilot, Mr. Wyman, jumped from his room; I also sent him below with orders to find out what he could in regard to the accident, whether they could work the engine, whether the schooner had cut in deep enough to fill us with water, also, if so, for the chief to start the pumps.

I waited a reasonable length of time. Then about that time Mr. Staples came back, but passing through steam, with which the boat had become enveloped at that time, he was unable to speak for a moment.

Pilot Wyman, who then appeared on the scene, said that the chief said to beach her as soon as possible. I asked Pilot Wyman if the chief said we could work the engines; he said "Yes." I stepped to the main gong and rang to go ahead, rang for engine to go ahead, called the quartermaster and pilot into the pilot house—they had stepped out of the pilot house door at that time—and told them to hold the wheel hard to port, that we would head up for Watch Hill for the beach.

I waited a reasonable length of time; got no response from the engine room. Then the men, officers and crew, and passengers were appearing around the pilot house. I told them all to go to their stations and get their boats ready, realizing by this time that the steamer was sinking fast. I told them to do all they could, to save all they could.

Then I also sent the first pilot and a porter to look around and see if there was any steamers in sight that we could signal to. I realized that it was useless to blow the whistle, as it was blowing such a heavy wind that unless it was a vessel to the leeward of us she would not hear the whistle. The porter and first pilot returned, saying that there was no steamers [sic] in sight.

I then went to the starboard side where my boat was located. The steamer by that time had a heavy starboard list and was enveloped in steam, especially around midships, smokestacks, etc.

The men were getting the boats ready. I remarked to the first mate, whose boat was just aft of mine, that it would be impossible to save any on that side of the steamer, being the windward side, the steamer having swung around to the southward. I also remarked that there was bound to be great loss of life, but that we must endeavor to get our boats around onto the leeward side and save what we could.

While the men were working on my boat, removing cover, lashings, etc, the chief engineer came over to my side, and said that he had his boat all ready. I jumped over there with him, and assisted him in swinging it out. Then, realizing how fast the steamer was sinking, and realizing that it was necessary to get out all of the boats, I told the chief engineer to save all that he could, take all that he could in his boat; I must go over and get my boat out.

The men had the boat started from the deck and we very soon swung her out over the side. As the steamer's starboard guard was under water, I jumped into my boat, called the others with me and the men who belonged to my boat who were standing around there. The boat was lowered away and we dropped her into the water and let go of the falls. We then manned the boat and the oars; I took a steering oar, intending to go around to the leeward side where we could save people.

We dropped down around the bow of the boat, got in the trough of the sea, broadside to the wind, and try as hard as we could, every way that we could think of, backing on one side and rowing on the other and working the steering oar, we found it impossible to bring her around head to it, drifting away from the steamer all the time, and still endeavoring to get up to her.

Almost before we could realize it the steamer was down. We stayed around as close to the steamer as we possibly could, endeavoring to rescue any that might be seen. We saw a number of boats go out of sight in the darkness. We stayed around until everything had disappeared from our view, then decided that the only thing to do was to let her drift. We drifted to Block Island.

2

THE SCHOONER
HARRY KNOWLTON

The *Harry Knowlton* was a three-masted schooner built in 1890 in Tottenville, New York. The ship was 128.7 feet long, 33.5 feet wide and 11.1 feet in depth. The vessel's registered port was Eastport, Maine. George B. Dunn of Holton, Maine, and Jacob Housman of Port Richmond, New York owned the *Harry Knowlton*. Frank T. Haley was its master at the time of the collision. The ship was engaged in the coasting trade, and on the day of the collision, the official record states that the ship was transporting 453 tons of coal from New York, New York, to Everett, Massachusetts.

Once loaded with coal, it left South Amboy, New Jersey, on its way to Everett, Massachusetts. Schooners such as the *Harry Knowlton* were numerous, carrying most of the goods needed for the ever-growing New England population.

The men that sailed in these merchant ships came from all over the world and from all occupations. The men on the *Harry Knowlton* were no different; however, those in charge of the *Knowlton* were robust New Englanders, well versed in the navigation and control of their ship and its crew. Vessels such as the *Larchmont* and the *Harry Knowlton* had to strictly follow maritime regulations, which governed the way they would operate in open waters and along the coast. In the case of two vessels with different power sources—such as the *Harry Knowlton*, powered only by the wind, and the *Larchmont*, which provided its own power and was capable of much greater maneuverability in all weather—the vessel under sail would be granted greater latitude when the two came within sight of each other.

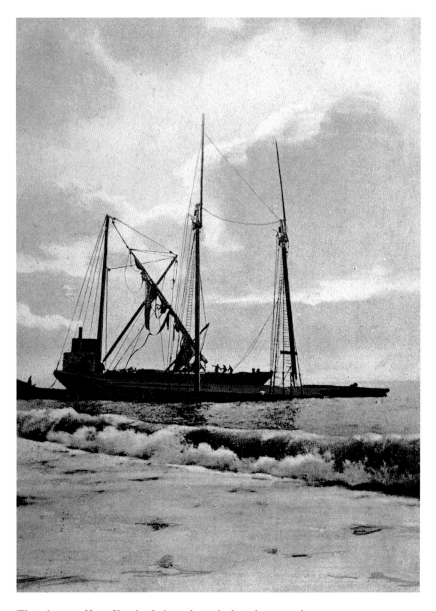

The schooner *Harry Knowlton* being salvaged where it came ashore.

On the morning of February 11, 1907, with a break in the weather, the *Harry Knowlton* set sail for Everett, Massachusetts, after being icebound for several days at City Island at the entrance to Long Island Sound. Prior to the ship being icebound, a major snowstorm that had hit New

England dropped over seventeen inches of snow along the coast, and temperatures dropped below zero. The record-breaking cold and heavy snow brought transportation to a crawl, with many ships becoming icebound along the coast. As for the schooner *Harry Knowlton*, the ice blocking the exit began to break up.

The *Harry Knowlton* was built to carry cargo. It weighed 317 gross tons and was designed to carry 500 tons. After it was first built, it was used to transport salted fish to South America and the West Indies, returning loaded with salt. In later years, it began transporting Pennsylvania coal from New Jersey to Maine. Pennsylvania coal would be excavated from the earth and loaded into rail cars where it was transported to shipping ports in Amboy, New Jersey. Ships from all along the coast would haul coal from Amboy to various ports up and down the coast, supplying New England with the fuel needed for its homes and factories.

At 9:00 p.m. on February 11, 1907, the schooner *Harry Knowlton* passed Race Rock Lighthouse, heading east. The wind was blowing heavy from the northwest. The ship, with its sails full of wind, was moving at a speed of over eight knots. Sometime after 10:00 p.m., the lights of a steamer were noticed off in the distance by a crew member aboard the *Harry Knowlton*.

The captain of the schooner, who had come up from his cabin after hearing the crew talking worriedly about something, noted the red light of a oncoming ship approaching from 150 yards in the distance. The captain ordered his helmsman to keep the ship on its present course. Within minutes, the two ships collided.

As the days after the collision passed, the enormity of the disaster, caused by what seemed to be blatant incompetence, and concern regarding steamship travel spread across the country. As public confidence in the safety of passenger steamers—which were an important section of the economy—began to wane, political influence was brought to bear in an effort to calm the public. An official investigation into the collision began.

Primarily, the United States Steamboat Inspection Service carried out the investigation into the collision between the steamer *Larchmont* and the schooner *Harry Knowlton*. Officials of the United States Steamboat Inspection Service traveled to the site where the schooner *Harry Knowlton* came ashore and took statements from the crew.

Frank T. Haley, captain of the schooner *Harry Knowlton*, was one of the first to give a statement. Officials wanted to know what happened onboard the schooner at the time of the collision and asked Captain Haley if any of the crew was injured. Captain Haley replied:

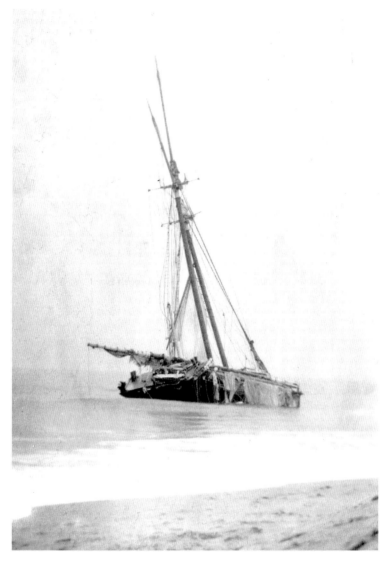

The schooner *Harry Knowlton* with wreckage of the steamer *Larchmont* embedded in its bow.

When the impact came all the men except the mate, Borgeson, Johnson and I were below. The members of the crew were asleep in the forecastle. Van Louck was in the upper bunk on the starboard side, and when the crash occurred, he was hurled violently across the forecastle and landed in a heap on the opposite side of the ship. Dazed and shaking, he gathered himself

up, came scrambling on deck, and wanted to know what had happened. I sent him below to rouse the other men. Next aft of Borgeson's bunk was one occupied by Nickerson, who was not awakened by the collision, but was sleeping peacefully when his shipmate went below to warn the other men of the danger. The Steward is subject to rheumatism, and this morning after we came ashore he was unable to walk except with difficulty.

T.A. SCOTT COMPANY

Agents of the schooner *Harry Knowlton* hired the T.A. Scott Company to salvage what it could of the beached schooner and remove the wreck from where it had came ashore, half a mile from the Quonochontaug Life-Saving Station. On February 17, 1907, the T.A. Scott Company sent the tugboats *Harriet* and *Eva* to the site where the schooner *Harry Knowlton* went aground to begin removing the cargo of coal within the schooner's hull.

John H. Gurncy, an employee of the T.A. Scott Company, gave testimony on February 21, 1907, in New London, Connecticut. Gurncy stated to officials that he was an employee of the T.A. Scott Company as a master of the tug *Cassie*. He told officials he had about twenty years of experience in both sailing and steam vessels. Officials asked Gurncy several questions

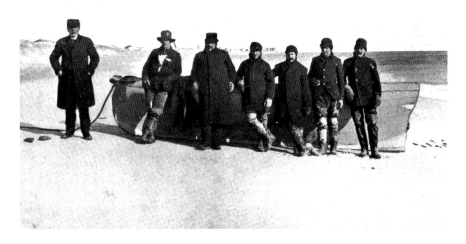

The crew of the schooner *Harry Knowlton*, taken the day after the collision with the steamer *Larchmont*.

about his involvement with the schooner *Harry Knowlton*. He replied to the questions, acknowledging that his first visit to the beached schooner was on Sunday, February 17, 1907. He arrived at about 8:00 a.m. at the site onboard the tugboat *Harriet*. The vessel *Eva* arrived with them. Officials asked what he saw when he reached the beached schooner. Gurncy stated that a part of the wreckage, believed to be a steamer's deck, was projecting out from the beached schooner, along with a guardrail that certainly did not belong to a sailing ship, confirming that the schooner *Harry Knowlton* had been in a collision with a steamship.

Below is a list of the captain and crew of the steamer *Harry Knowlton*:

Frank T. Haley; captain; age fifty-eight; from Everett, Massachusetts.

Frank Govand; mate; from Bangor, Maine.

Robert Waycott; steward; age forty-seven; from Saint John, New Brunswick, Canada; who had a wife and seven children.

Carl Julies Borgeson; bow watchman; age twenty-four; from Christiana, Norway.

Harry Van Louck; age nineteen; from Holland.

Carl Victor Johnson; helmsman; age thirty-seven; from Sweden.

Edwin Nickerson; age thirty-five; from Sweden.

THE PASSENGERS AND LIFESAVERS

The passengers aboard the *Larchmont* on the night of the collision came from all walks of life, some traveling for business purposes and others traveling for pleasure.

One couple in their early twenties was just married. They were traveling to New Jersey, where the groom had secured a new job, to begin their new life together. An entire family was traveling to New York for their son's wedding, and many others aboard that night were en route to New York, where they would then go on to overseas destinations. Also onboard were several members of the Salvation Army who were en route to a meeting of the Eastern Scandinavian Corps of the Salvation Army held in New York.

SALVATION ARMY

Emma Backlund and Alma Johansen received word in January 1907 that they were accepted for officer training at the Salvation Army center located in New York. This honor was given to them because of their high morals and integrity along with their excellent work as Salvation Army apprentices.

The girls, after receiving word of their acceptance for training in New York, booked travel arrangements through the Joy Line. The two girls, along with eight others from the Salvation Army, boarded the steamship *Larchmont* on February 11 for their trip to New York.

Four passengers posing for a photo in front of a lifeboat.

Aboard the *Larchmont* that night, just prior to the ship going beneath the waves, the brave Salvation Army workers, knowing their fate, encouraged their fellow passengers to make peace with God. During this time of utter helplessness, they joined hands and began to sing the last verse of "Rock of Ages, Cleft for Me."

Only three of the ten bodies of the Salvation Army members were recovered after the collision. A memorial service for them was held at the Carnegie Music Hall in New York on February 18, 1907. Well over five thousand people attended the service, and over five thousand others had to be turned away due to the lack of space. The three caskets, covered with the colors of the Salvation Army and with a United States flag, were placed in the center of the hall. At the memorial, as well as at other occasions honoring them, the ten who died were highly praised for showing not only how a Salvationist can live but also how a Salvationist can die.

Eastern Scandinavian Province of the Salvation Army list of members who lost their lives in the *Larchmont* disaster on February 11, 1907:

Emma Backlund, Quinsigamond Village, Worcester, Massachusetts.
Alma Johansen, Quinsigamond Village, Worcester, Massachusetts.
Captain Olga Hellgreii, Lynn, Massachusetts.

Captain Anna Rundorg, Lynn, Massachusetts.
Captain Richard Swan, Worcester, Massachusetts.
Lieutenant John Mollne, Worcester, Massachusetts.
Arona I Jefvendahi, Cambridge, Massachusetts.
Captain Elin Lambert, Cambridge, Massachusetts.
Captain Anna Oden, Worcester, Massachusetts.
John Cederbloom, Lynn, Massachusetts.

LIFESAVING STATIONS

From colonial times to the present, lifesaving after a maritime disaster has evolved from the volunteer service it was at its beginnings to the modern and efficient service it is today.

The roots of the United States Life-Saving Service were derived from the Humane Society of the Commonwealth of Massachusetts that began in 1785. The country's first lifesaving station was put in service in 1807, located in Cohasset, Massachusetts. It soon proved its importance in saving lives. The ever-increasing ship traffic off the coast brought with it many marine disasters. The need increased for the establishment of a service, overseen by the government, that could take on the important job of lifesaving.

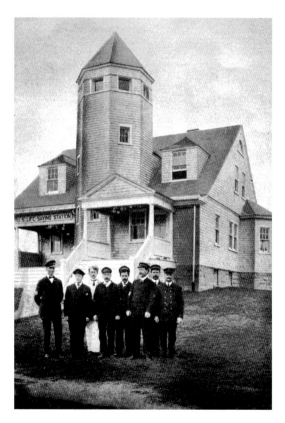

The lifesaving station and crew at Watch Hill, Rhode Island.

In 1848, the federal government adopted legislation that recognized the need for lifesaving after a maritime disaster. As a result of the new legislation, a lifesaving station was built at Watch Hill, Rhode Island, in 1850. As one of the first to be built, it was a place of learning for the new service. The station was equipped with surfboats and lifesaving equipment and was manned by volunteers from around the area.

With a steady increase in maritime incidents over the next several years, further changes were needed to make the service more effective. To achieve this, the Revenue Marine Bureau was reformed, and in 1871, it took charge of the America's Cutter Service and the lifesaving stations.

SURFMEN

As more lifesaving stations were built and came into service, surfmen, as they were known, were needed to operate the stations. A typical station had six surfmen and a keeper whose job it was to oversee the station and its crew. Individuals from the surrounding towns were recruited and trained in the profession of lifesaving. During the early years, personnel operating the various stations were volunteers. After the reforms of 1871, surfmen and keepers at many stations were paid for their service. In 1907, at the time of the *Larchmont* disaster, the average surfmen were paid fifty dollars a month. Surfmen at most stations held regular lifesaving drills, learning how to act as a team during a disaster.

Along with the constant training and daily duties around the station, the surfmen were required to patrol the beach and keep watch for ships in distress. The danger for surfmen was high. Being out in treacherous weather in a surfboat or wading out into the violent surf to rescue an unfortunate victim put many surfmen in mortal peril.

On numerous occasions, surfmen froze to death or drowned attempting to rescue passengers and crew of a ship that came too close to shore and wrecked on the rocks. The lifesaving station itself became a sanctuary for those rescued from a disaster. He or she would be brought to the nearest station after being rescued and be provided with food, clothes and shelter.

Training of the crew at most lifesaving stations consisted of several aspects. Training in the use of surfboats, one of the most important pieces of equipment for the crew of the lifesaving station, was paramount. Launching

a surfboat in bad weather was difficult due to the high waves, frigid cold and high winds coming in off the ocean.

Another important piece of equipment that required a great deal of training was a line-throwing gun. The gun was designed to fire a thin rope, also called a lifeline, to a stranded ship off in the distance. Once the stranded vessel received the rope, a heavier rope could be attached and drawn back. Once both ropes were secured, a life preserver buoy could be attached and used to ferry those being rescued to shore.

Many improvements to this gun were made, and by 1880, a lifeline could be shot a third of a mile. Lifesaving crews were also trained in the uses of various communication equipment. Signaling devices used to communicate between lifesaving crew members and ships offshore consisted of rockets, flares and flags.

Communication with the use of flag signals became widely used, enabling a ship offshore to communicate with those on land. This became an important tool for a ship in distress to communicate its condition or danger. Other advances in communication such as the telegraph, the telephone and wireless technology greatly improved communication and, thus, the outcomes of maritime disasters.

Rhode Island, with over 350 miles of coastline, has seen many maritime disasters. In Rhode Island, the establishment and expansion of the lifesaving service from colonial times until the early part of the nineteenth century was gradual. In 1872, Block Islanders welcomed the establishment of a lifesaving

Passengers relaxing on the deck of a ship while underway.

station. The New Shoreham Station was established in 1874, and the Sandy Point Station was established in 1898.

Other stations constructed in Rhode Island were the Watch Hill Station, established in 1879; the Point Judith Station, established in 1876; the Narragansett Pier Station, established in 1872; the Brenton Point Station, established in 1884; Quonochontaug Station, established in 1891; and the Green Hill Station, established in 1912. Most stations were built at prime vantage points, where they could be best utilized in the event of a disaster.

The buildings' architectural designs and layouts changed over the years. Almost all of the lifesaving stations built in Rhode Island had their own unique design and layout. The interiors of the buildings were laid out to aid the crew's ability for a quick response in responding to a disaster.

GOLD CARNEGIE MEDAL FOR HEROISM

The Carnegie Hero Fund Commission announced that the commission would award medals and money to several people involved in the rescue efforts after the *Larchmont* disaster. Eight crew members of the schooner *Elsie* were given gold medals for their valiant efforts in rescuing victims of the *Larchmont* disaster.

The *Elsie*'s crew was successful in rescuing eight passengers who were aboard the steamer *Larchmont* after the collision with the schooner *Harry Knowlton* on February 12, 1907. The gold medals presented weighed almost one pound each. The eight crew members of the schooner *Elsie* given gold medals were: Captain John W. Smith, fifty-eight years old, who was also given $4,000 for the education of his two sons; Albert Smith, forty-six years old, brother of John W. Smith, who was also given $4,000 for the education of his two daughters; George E. Smith, fifty-one years old, who was also given $2,000 for the education of his son; a nephew, Harry L. Smith, twenty-four years old, who was also given $1,000 for the purchase of a home or some other worthy purpose; Earl A. Smith, twenty years old, who was also given $2,000 for the education of his son; Louis N. Smith, a nephew, nineteen years old, who was also given given $1,000 for the purchase of a home; Jeremiah M. Littlefield, forty years old, a brother-in-law of Captain Smith, who was also given $2,000 for the education of his son; Edgar Littlefield, thirty-five years old and a brother of Jeremiah, who was also given $6,000 for the education of his three children.

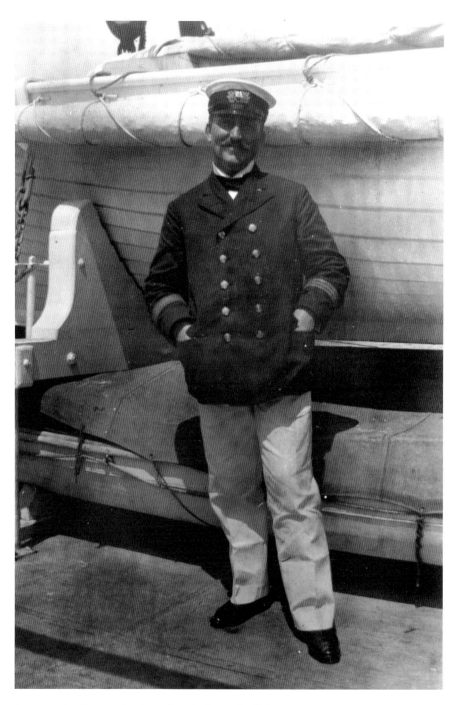

A steamship officer posing for a photo in front of a lifeboat.

Other medals as well as certificates were awarded to individuals for their heroism and assistance in searching for victims after the disaster. Crew members of the fishing boats *Theresa* and *Clara E.* received medals and awards in a ceremony that was held on May 16, 1907.

The tugboat *Chickasaw* and its crew's efforts to render aid after the collision between the steamer *Larchmont* and the schooner *Harry Knowlton* were also acknowledged. After receiving word of the collision, the navy dispatched the tugboat *Chickasaw* from the navy's torpedo station located in Newport. The *Chickasaw*, however, had to turn back due to severe weather. The *Chickasaw* was a few miles off the coast of Block Island when the small tugboat began taking on water from a breach in the hull. The crew reluctantly gave up its rescue efforts, turned the tugboat around and headed back to Newport.

INVESTIGATION AND OFFICIAL REPORT

A fter the collision between the schooner *Harry Knowlton* and the steamer *Larchmont*, news of the horrific disaster spread, and for many days after, the facts of the collision were front-page news across New England. The gruesome details of that night created frenzy, bringing newsmen from all parts of the country to Westerly and Block Island, Rhode Island. One of the first reports of who might be responsible for the collision comes from Captain McVay of the *Larchmont*. He told reporters that the captain and crew of the schooner *Harry Knowlton* caused the collision. He said that if the *Knowlton* had held true to the course on which it was sailing when first spotted by the crew of the *Larchmont*, a collision would not have occurred. Captain McVay said, however, that the schooner suddenly turned into the port side of the *Larchmont* before his helmsmen could maneuver to the left.

A sounding rebuttal came from Captain Frank Haley of the schooner *Harry Knowlton*. He claimed the fault of the collision rested with the captain and crew of the steamer *Larchmont*. A thorough investigation of the collision began on February 12, 1907. Captain William E. Withey of the United States Steamboat Inspection Service was appointed to head the investigation. Within days, sworn statements and other relevant information regarding the collision was obtained from several who survived. The graphic accounts given by the survivors of the *Larchmont* shocked even those investigating the collision.

As personal accounts of the tragedy were reported in many newspapers, disbelief of the actions of the captain and crew of the steamer gripped

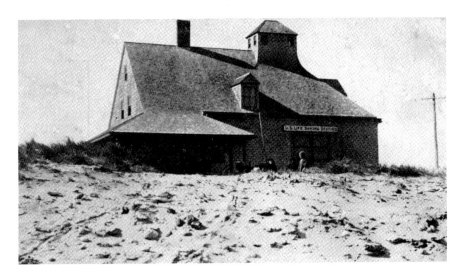

Sandy Point Life-Saving Station in Block Island, Rhode Island.

readers across the country. As these accounts were verified, the disbelief turned to anger, and the public demanded accountability for this needless tragedy. Both captains involved in the disaster still blamed each other for the collision.

The first details regarding the disaster came from Captain McVay of the *Larchmont*. His account of what occurred prior to and after the sinking of his ship favored his actions and those of his crew. However, personal accounts of those who survived the sinking of the *Larchmont* were in stark contrast to Captain McVay's account. A statement by Captain McVay, made days after the collision, claiming that he was the last to leave his sinking ship was investigated. Because of the conflicting statements made by a few of the survivors claiming that Captain McVay and his crew were the first to fill the lifeboats, abandoning and ignoring the passengers' frantic cries for help, investigators sought out more details from those crew members of the *Larchmont* who survived that night.

One fact seemed evident from the information gathered by the inspectors: moments after the collision, many of the passengers asleep in their beds were awakened by the sound or by the feeling of the shudder and rumble beneath them. Only those who dressed and made their way topside immediately after the crash would have enough time to secure a place in the lifeboats, which departed within minutes of the collision.

For many who waited to clothe themselves properly, the first blast of zero-degree wind drove them back to their rooms. Many, however, found their

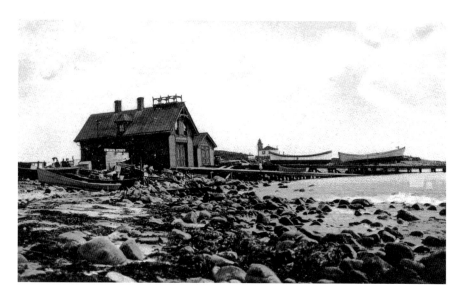

Watch Hill Life-Saving Station.

rooms flooded with the frigid waters of the Atlantic. Investigators estimated that over 143 men, women and children perished. The question loomed: why, out of the nineteen who survived that night, were ten of those members of the crew and only nine passengers? Out of the nineteen who reached Block Island alive, one died shortly after his arrival on the island and two others died in Providence days later.

PUBLIC ANGER

Within days of the collision, an effort to locate the steamer *Larchmont* began. The *Larchmont*'s estimated position before sinking was explored, but its remains at the bottom of the Atlantic were not located. As the investigation into the collision went forward, many who helped in the rescue of the survivors began to come to a conclusion about the accident. Feelings ran strong that the tragedy was a clear case of criminal carelessness, that the estimated 143 people perished in the freezing cold on that February night due to the negligence of the captain of the *Larchmont* and that the collision could have been easily avoided.

These feelings were confirmed in the official findings of the steamboat inspectors' investigation. The investigation concluded that the schooner

An officer sitting on the deck of a ship while entering New York Harbor.

Harry Knowlton and the steamer *Larchmont* approached each other in such a way as to involve risk of collision; however, the schooner *Harry Knowlton* was navigating in full compliance with the provisions of article twenty-one of the Steering and Sailing Rules for Atlantic and Pacific Coast Inland Waters. It further states that the movements of the *Larchmont* were in direct violation of articles twenty and twenty-two of the said rules. Therefore, the inspectors attributed the loss of the steamer *Larchmont* and schooner *Harry Knowlton* to careless and unskillful navigation on the part of the first pilot of the *Larchmont*, John L. Anson.

In testimony given by the passengers fortunate enough to survive the disaster, the lack of response to the crisis by the captain and crew seemed obvious. The steward's orders to crew members not to alarm the passengers or hand out life vests clearly showed the lack of understanding of the peril of the situation at the time when proper action to the situation could have saved lives.

The unfortunate fact that the captain or officers seemed not to grasp the severity of the situation and did not act in ways that would have improved the outcome of the situation seemed beyond comprehension.

The order to fire flares, which would have signaled their distress and brought aid, was not given. Many believed that if the order was given to launch flares shortly after the collision, a passing ship or a surfman from the Quonochontaug or Watch Hill Life-Saving Stations patrolling the beaches would have noticed and investigated.

Several weeks into the investigation, public sentiment continued to run high concerning the *Larchmont* disaster. Events, however, in the latter days of March took the focus off the *Larchmont* disaster and placed it on the nation's financial condition. A frenzied panic began on March 25, 1907, over the nation's stock market.

Many people, believing the press's prediction about a stock market meltdown, began selling their stock, creating the nation's first stock exchange panic. The country's economy and financial condition now consumed the public's interest. As this crisis unfolded, the findings of the investigation of the *Larchmont* disaster were released in an initial report by the secretary of commerce Oscar S. Straus and went virtually unnoticed by the public.

Changes were eventually made regarding steamship travel and safety for passengers. Over the next several years, controversy over the collision between the steamship *Larchmont* and the schooner *Harry Knowlton* continued for those touched by the disaster.

In mid-March 1907, a month after the collision, the Joy Line Steamship Company presented a petition to the admiralty branch of the United States District Court in New York. Soon after, Judge Adams issued an order

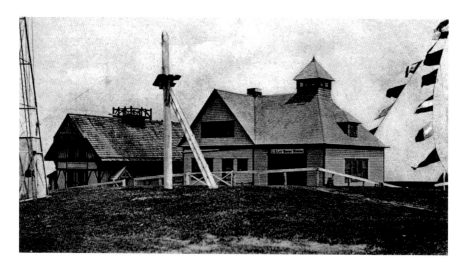

United States Life-Saving Station at Point Judith, Narragansett Pier, Rhode Island.

limiting the total responsibility of the owners of the *Larchmont* to $143.12, the value of the property recovered after the incident.

Officials from the Joy Line presented a list of the property recovered after the accident and asked that a trustee be assigned to handle all claims. The value of the property recovered was listed as: one lifeboat and some life preservers valued at $40.00, freight valued at $8.12 and $95.00 in passenger fares taken from the purser of the *Larchmont*. After all claims had been received and satisfactorily proven, the total amount of the $143.12 was to be divided up between the claimants.

Extensive efforts were made to find the location of the sunken steamer. On February 25, 1907, the T.A. Scott Company conducted soundings at the location where the steamer was believed to have gone down in an effort to determine the depth of water. The company took several readings within a one-mile radius, finding depths between twenty and twenty-five fathoms.

The remains of the steamer *Larchmont* lay upright, some 130 feet beneath the waves, three and a half miles southeast of Watch Hill, Rhode Island. The remains of the ship were located in 1964. Since then, the site has become a popular diving location.

CURSED SHIP

The circumstances leading to the misfortune of the *Larchmont* might not have been exclusively the fault of the captain and crew; however, these events left many believing the vessel to be unlucky and some believing it cursed. Many started referring to the *Larchmont* as the "the HooDoo Boat." The first event that led to the *Larchmont*'s cursed reputation—and what many believed could have been a major disaster—was the collision and sinking of the *Cumberland* in Boston Harbor on Monday, July 7, 1902. It would have been a tragedy had it not been for the quick response of Captain Allen and his decision to bring the ship to port and not wait for assistance at the site of the crash.

On September 3, 1902, after being in service with the Joy Line just a short time, a fire broke out below deck, which could have been disastrous to the vessel, passengers and crew. The fast reaction of the captain and crew kept the situation under control. The fire was extinguished within a half hour, and the vessel was once again underway.

On January 13, 1904, the ship ran aground off Prudence Island. With the assistance of the tugboats *Roger Williams* and *Solicitor*, the *Larchmont* was

pulled free and suffered little physical damage. A few weeks later, the vessel was again run aground in Narragansett Bay. It was able to free itself this time a few hours after grounding with the help of the rising tide.

The discovery of the murdered body of John Hart had added to the rumors of the *Larchmont* curse. On the evening of Saturday, February 18, 1905, John Hart had boarded the *Larchmont*. The twenty-five-year-old man was shot in the head by a .32-caliber gun while he slept. The coroner estimated the murder was committed at about 2:00 a.m. No one had heard the shot. John Carey, also known as Jack Irish, the piano player on the *Larchmont*, was accused of the murder and tried in Providence. Owing to the lack of evidence, Carey was soon after released. Hart's murder was never solved.

THE JOY LINE

The Joy Steamship Company, also known as the Joy Line, was formed in February 1899 by J. Allen Joy, Frank M. Dunbaugh and Charles L. Dimon. The three had engaged in risky business ventures in the past and believed that an affordable steamship line operating in Long Island Sound would be a successful endeavor. Named after one of its founders, the Joy Line was established primarily to operate two routes, the first being New York to Providence and the second between New York and Boston. This newly formed steamship line would begin transporting passengers and freight between New York and Providence.

The years after the formation of the Joy Steamship Company were challenging. Competition from other newly formed steamship companies as well as the older and more well-established lines tested the company's resolve and determination.

Many popular steamship companies operated steamship routes in Long Island Sound in the latter part of the 1800s. Some of the well-known lines during the time of steamboat travel were the Fall River Line, the Metropolitan Line, the Stonington Line, the Providence Line, the Norwich Line, the Hartford Line, the Montauk Line, the Bridgeport Line, the Narragansett Bay Line, the Bay Line and the Old Dominion Line.

The steamer *State of Maine* in Portland, Maine.

1899

Incorporated in the state of New Jersey on February 25, 1899, the Joy Line was formed with Frank Dunbaugh as president, J. Allan Joy as secretary-treasurer and Charles L. Dimon as general manager. The company's first steamship was acquired from Dimon, and the steamer began transporting passengers and freight on March 19, 1899. The steamer, named the *Rosalie*, made its first voyage from New York, New York, to Providence, Rhode Island.

Several other well-established steamship lines operated steamers along the New England coast. Many ports located in places like New York, Boston and Providence became transportation hubs for passengers and freight. Competition from the paying passengers and businesses looking for the cheapest way to haul freight created tension between the many steamship lines operating in Long Island Sound.

As for the Joy Line, it established itself as a low-cost steamship line, and with a small steamer like the *Rosalie*, it could compete successfully with the other lines that operated larger steamers, which cost much more to operate. This gave the Joy Line the edge it needed to establish itself as a reliable and reputable steamship line.

The steamer *Rosalie* was a relatively small steamer compared to other steamers plying the waters of Long Island Sound. Built primarily to haul freight, the small

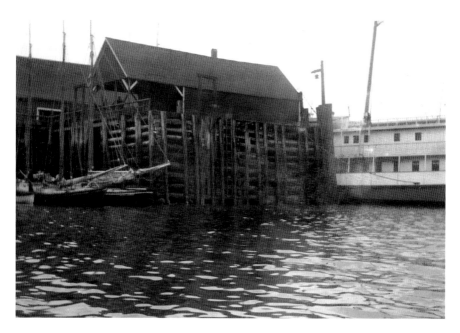

On the right is the *Larchmont* tied up at dock.

steamer was constructed with an exceptionally strong hull. This made it well suited to withstand the severe New England weather. In Providence, Rhode Island, the Joy Line acquired a lease on a wharf just south of the Point Street Bridge. This location was ideal for the new steamship line because it was in proximity to the Providence Line, Clyde Line and other competitors.

The numerous wharfs that lined the busy Providence waterfront bustled with activity. Besides the many steamers that landed in and departed from Providence, other vessels of all types sailed in and out of the harbor daily. Throughout 1899, the steamer *Rosalie* departed from Providence twice a week for New York. Passengers and freight traffic on this route increased dramatically and became a steady source of revenue for the new company.

Over the next several years, the Joy Line grew. It needed to purchase additional steamships to add to its fleet. All of the ships acquired were secondhand. Several ships were bought after being damaged in an accident or by the weather; most were purchased at a discount price. This earned the Joy Line the distinction of being cheap. The steamship *Cape Charles* was acquired and began service transporting passengers and freight for the Joy Line in early 1900.

The *Cape Charles* was built in 1897 for the Norfolk Cape Charles Line but had caught fire on December 16, 1898. The ship was severely damaged and

sold to the Joy Line at a discount price. After purchasing the ship, the line refurbished it to haul freight and renamed it *Allen Joy*. The Joy Line, over the next several years, would charter ships from other steamship companies. The company found this practical when it did not have enough ships of its own available to meet demand.

THE STEAMER *ROSALIE*

The steamer *Rosalie*, the first vessel operated by the Joy Line, made its first trip on March 19, 1899. Compared to other steamers operating along New England's coast, the steamer *Rosalie* was relatively small, being only 144 feet long and built primarily to haul freight.

1900

The Joy Line started the year 1900 with the acquisition of a steamer called the *Old Dominion*. Owned and operated by the Old Dominion Line, the ship operated as a passenger steamer on the Old Dominion Line's New York City to Richmond route. The company decided in late 1899 to discontinue the ship's use on this route. The Joy Line, seeing an opportunity, acted swiftly and purchased the ship at a bargain price.

The *Old Dominion* was a large ship, constructed in 1872, that had seen a lot of use in its twenty-eight years of service. The ship, however, was well built and economical to run. These two facts, along with the low purchase price, made it a prime candidate for the Joy Line. In March 1900, a fire broke out aboard the *Old Dominion* while tied up at its dock in New York. The fire burned for over an hour before it was extinguished.

The ship, then being severely damaged and needing over $10,000 in repairs, created a crisis for the Joy Line. The worst part of the situation was that the needed repairs would take over two weeks, putting service on hold for the Providence to New York route. For the first two weeks of April 1900, backlogged freight accumulated on the Joy Line wharfs, and the needed cash flow dried up. The Joy Line scrambled to stay solvent while trying to come up with a solution. The company was able to charter a ship to fill in for the *Old Dominion*. The steamer *Santuit* was chartered and sailed from Boston to

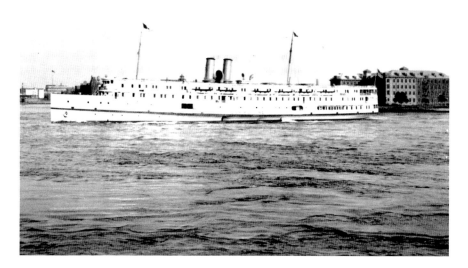

The steamer *Comet* of the Colonial Line.

New York and back again, hauling passengers and freight for the Joy Line. This, along with repairs to the *Old Dominion* completed earlier than expected, brought an end to the crisis.

In early May of that year, the Joy Line once again came across a steamer that was being sold at a bargain price. At that time, the Joy Line was looking for a ship for its Providence route. The company acquired the steamer *Seaboard* from the Tampa and Mobil Line and began using it on the Providence to New York route in mid-May. Built in 1874 for the Old Bay Line, the steamer *Seaboard* was 180 feet long and designed to carry a large amount of freight. Prior to the purchase, the *Seaboard* was in an accident. In February 1899, a schooner in New York Harbor collided with the *Seaboard*. Badly damaged and sinking, the crippled steamer was towed to a repair yard where temporary repairs were made. That year, it would be put up for sale and sold.

In June, the Joy Line decided to expand its passenger service on its Providence to Boston route. The company chartered a small steamer called the *Martinique*. On June 12, the steamer began service for the Joy Line, hauling passengers and freight. By adding the *Martinique*, the Joy Line was able to expand its ability to service more passengers, bringing in needed revenue to sustain the new company.

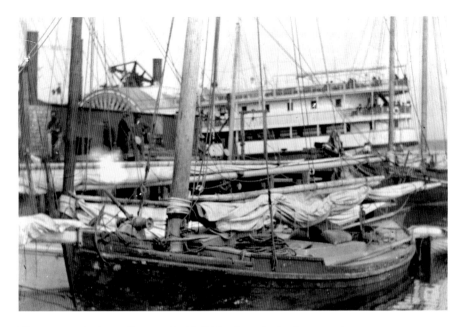

The steamer *Larchmont* (far center) with fishing boats in the foreground.

In October, the charter for the *Martinique* ran out. The company, seeing profitability in having another ship on this route, needed to find a ship to take over for the *Martinique*. The company was able to charter the steamer *Shinnecock*, from the Montauk Line. Built in 1896, the *Shinnecock* was 226 feet long and 35 feet wide. The charter of the *Shinnecock* worked out well for the Joy Line, showing that the company could compete with the bigger, more well-established steamship lines.

1901

The Joy Line began the New Year with the acquisition of another steamer. The company had an opportunity to buy a used passenger steamer at a bargain price. The Boston Portland Line put up the *Tremont*, a steamship that was retired from service, for sale. The *Tremont* was built in 1883 at the John Englis and Son Shipyard in Greenpoint, New York. The ship had 104 staterooms, was 260 feet long and 37 feet wide and weighed in at 1,428 tons. Well built, the *Tremont* was adorned with ornate woodworking and furnishings. At the time of purchase, the Joy Line estimated the *Tremont*, though old, still had many years of service ahead.

In June, the charter ran out on the *Shinnecock*, leaving the Joy Line once again in search of a steamer for its New York route. The steamer *Penobscot* of the Boston-Bangor Line had just been put up for sale at a reasonable price. Officials from the Joy Line decided it was better to purchase a steamer for the New York route rather than try to find an adequate ship to charter. The steamer *Penobscot* was purchased and began service on June 24 of that year.

In the early morning hours of July 6, 1901, the steamer *Old Dominion* ran aground while en route to New York. While assessing the situation, it was discovered that the hull of the ship was severely damaged, and the ship, with over one hundred passengers aboard, was in jeopardy of sinking. During the day, the passengers and freight onboard the ship were transferred to another ship. Several attempts were made to free the *Old Dominion* from the rocks. Unable to free the ship, the Joy Line decided to dynamite the rocks holding the ship in place. One month after it ran aground, the ship was freed.

Another accident had befallen the Joy Line that month. On July 16, the steamer *Tremont* was struck by a steam yacht named the *Wild Duck* while en route to New York, New York, with over three hundred passengers onboard. Owing to good fortune, other steamships were in proximity of the collision and quickly came to the *Tremont*'s aid.

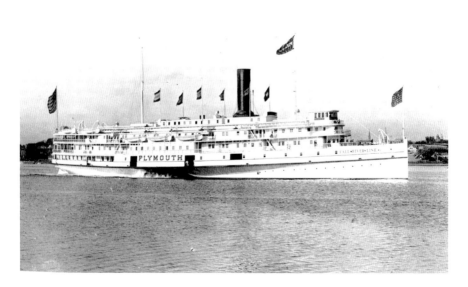

The steamer *Plymouth* of the Fall River Line.

The passengers onboard the *Tremont* were quickly transferred to other ships. Later, the *Tremont* was towed into New London and beached. Temporary repairs were made, and the *Tremont* was brought back to New York for repairs. The company dealt with the misfortune of the two bad accidents in one month the best it could. Over time, the *Old Dominion* was repaired and returned to service. After a month of repairs to the *Tremont*, it, too, was able to return to service.

The company once again needed another steamer to fulfill the increase in demand on the New York route, so the company charted the steamer *Virginia* from J.W. Wainwright with the provision that the ship could be purchased if it worked out better than planned. The *Virginia* was built in 1879 and was noted for its stylish form and ornate woodwork. The ship, however, needed work done to it to improve its potential on the busy New York route, so additional staterooms were added. After the work was completed, the *Virginia* was put in service.

The year 1901 was difficult for the Joy Line. The company managed to stay in business despite two of its ships nearly sinking. Throughout the turmoil, the company pulled together. Once again, the Joy Line showed it could compete with the larger steamship companies operating in Long Island Sound.

1902

The year 1902 started badly for the Joy Line. On January 2, the Joy Line steamer *Seaboard* collided with a barge while heading into the East River. The collision occurred while the *Seaboard* changed course in an effort to avoid a sloop. The *Seaboard*'s damages were severe enough to keep it out of operation for several days, severely hampering daily operations.

The winter weather was bleak, with many steamship companies (including the Joy Line) having trouble keeping on schedule. This situation caused a delay in freight shipments. Several companies using the Joy Line as their primary shipper began looking elsewhere for a more reliable method of shipping. The *Seaboard* returned to service in March after two months of repairs. Its return enabled the company to fulfill its obligations and ship the backlog of freight that had accumulated on the Joy Line wharfs.

In mid-1902, a coal shortage caused by striking coal miners created a problem for many steamship companies, including the Joy Line.

Steamships of the day consumed large quantities of coal to fuel their boilers. As the situation wore on, any surplus of coal that remained quickly dried up, considerably driving up the price. Many steamship lines saw profits also dry up and began losing money. The coal shortage improved over time, and the price normalized, bringing profitability back to normal.

In August 1902, the Joy Line purchased the steamer *Cumberland*. The ship had sunk after a collision in Boston Harbor, and the insurance company that took possession of the steamer after the accident agreed to sell the ship to the Joy Line at a bargain price of $60,000.

After taking possession of the ship, the Joy Line repaired the *Cumberland*, renamed it the *Larchmont* and put it in service. A few days after the *Larchmont* began carrying passengers and freight for the Joy Line, the unlucky *Larchmont* narrowly avoided disaster. At 5:00 p.m. on September 3, while leaving New York, New York, en route to Providence, Rhode Island, a fire broke out aboard the ship. A pile of mattresses that was being stored below deck had somehow caught fire.

Smoke from the fire was noticed, and the captain ordered the ship stopped. The crew quickly manned the hoses and began to fight the fire, which had begun to spread and produce a large amount of smoke. The quick response from the crew and aid by several passengers brought the fire under control, and within half an hour, the fire was extinguished. The quick response and valiant effort of the crew and passengers were credited for saving the ship.

The steamer *Cepheus* of the Iron Steamboat Company.

Competition between the many steamship lines and the railroad kept the Joy Line busy. The Joy Line entered into an agreement with the railroad over freight and passenger rates. The agreement enabled the Joy Line to continue its discount rates without antagonizing the railroad, its most powerful competitor.

1903

The Joy Line started the New Year with optimism. It had a new agreement with its biggest competitor, enabling them to concentrate and expand its services. Misfortune would soon strike again though. On January 20, the Joy Line steamer *Seaboard*, while en route from New York to Boston, ran aground inside Narragansett Bay. The *Seaboard* left New York in heavy fog. Captain Kirby of the *Seaboard* had hoped the weather would improve. The ship had no passengers aboard but carried a large quantity of freight.

As the ship approached Dutch Island Harbor, the captain, seeing the weather conditions worsen, ordered the ship to head into Narragansett Bay. As the visibility worsened, the captain ordered the ship to proceed at half speed. The tide, however, ran fast and carried the ship out of the channel. Within a short time, the bow watchman alerted the pilothouse that he had seen a black buoy, warning them of a rocky reef. Unable to stop, the ship ran aground. As the tide went out, the weight of the massive ship bore down on the jagged rocks, holding the steamer in place. Help soon arrived in the form of two tugs, but it was too late—the hull of the ship had been punctured in several places by the jagged rocks.

Over the next day, freight from the *Seaboard* was unloaded onto other ships in an effort to lighten it. The Scott Wrecking Company was called in. After two weeks, the *Seaboard* was freed from the rocks. It was towed to East Providence for extensive repairs. After being out of service for several weeks and costing over $30,000 to repair its hull, the *Seaboard* returned to service. The Joy Line ended the year with the purchase of the steamer *Aransas*. The *Aransas* was a large oceangoing ship. It was 241 feet long and weighed 1,156 gross tons. Its hull was built of iron, and it had four bulkheads.

1904

The frigid weather during the first part of 1904 hindered the Joy Line and other steamship companies along the New England coast in keeping their steamers running on schedule. The steamer *Aransas* had been purchased by the Joy Line in 1903 and began service on January 16, 1904, on the Joy Line's Boston route.

The steamer *Larchmont*, which had only been in service for the Joy Line a short time, continued with its misfortune. On Sunday, January 24, en route from New York to Providence, the *Larchmont* ran ashore on a sandbar off Dyer Island near Newport. The *Larchmont* was carrying two hundred passengers and freight when it went off course in thick fog at 6:45 a.m. Two tugs worked for several hours to pull it out of the sand. The ship was undamaged and proceeded on to Providence, Rhode Island.

Two weeks after running ashore on a sand bar off Dyer Island, the *Larchmont* once again ran aground in Narragansett Bay. On Sunday, February 7, one day after leaving dry dock in New York with additional copper sheathing added to the hull, the *Larchmont* encountered fog near Warwick Neck and once again ran aground. After a few hours, the tide rose and the *Larchmont* floated off and continued on its route to Providence.

On Monday, February 8, another Joy Line steamer fell victim to misfortune. At 8:00 a.m., while tied up at a pier near the Manhattan Bridge, the steamer

Passengers on the main deck of a ship.

Tremont caught fire. The fire started in the galley, while the ship's cook was preparing breakfast for the crew, most of whom were asleep in their bunks. The fire spread quickly. The first pilot of the *Tremont* was George McVay—the same George McVay who was captain of the *Larchmont* at the time of its sinking.

His actions, however, on the morning of the fire on the *Tremont* were credited for saving nearly all of the forty-four people who were onboard that morning. First pilot George McVay ran through the burning steamer alerting those aboard. Of the forty-four onboard, forty-three made it off the ship alive. Firefighters on the scene made every effort to save the burning ship, but the fire could not be extinguished. The fire spread throughout the superstructure of the vessel, consuming the ship to the waterline. The ship soon sank, still tied to the pier, and was declared a total loss. The cargo onboard included two trained lions.

The lions were part of a circus act and were scheduled to be unloaded the previous morning, but a miscommunication among the deck crew caused the lions to remain tethered to a post on the freight deck. The Scott Wrecking Company was called in to remove the remains of the steamer from the ocean floor.

The Joy Line quickly searched for a steamer to replace the *Tremont*. Officials from the company realized how well suited the *Larchmont* was to

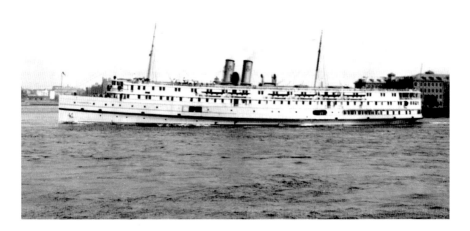

The steamer *Arrow* of the Colonial Line.

the company and wished to find another steamer equivalent to it. In early March, the Joy Line purchased the steamer *State of Maine* from the Eastern Steamship Company.

The *State of Maine* was an ideally suited ship. It was nearly identical to the steamer *Larchmont* and was built in 1882 by the New England Steamship Company in Bath, Maine. It was 141 feet long and 37 feet wide, weighing in at 1,409 gross tons. Just prior to its beginning service for the Joy Line, officials from the company renamed their new steamer *Edgemont*. Now the *Larchmont* had a nearly identical sister ship that would operate alongside it on the New York and Providence route.

Throughout the year, breakdowns occurred on several Joy Line steamers, most happening while en route. Many of these breakdowns were serious, and the ships were brought to the Morse Dry Dock and Repair Company in Brooklyn, New York. Three weeks after starting service, the Joy Line's newest steamer *Edgemont* had engine trouble while en route to Providence. The ship was towed back to New York where extensive repairs to its engines were carried out. It returned to service two months later.

1905

In 1905, the Joy Line celebrated its sixth year in business. The company believed that the experience it had gained within the past few years had left it able to operate much more efficiently than in the past. One situation occurred, however, that the Joy Line had no previous experience with—a murder. It happened aboard the steamer *Larchmont* on Saturday, February 18, while en route to Providence and left many onboard shaken and unprepared for dealing with the situation.

The *Larchmont* arrived in Providence at noon on Sunday, February 19, and tied up at the Joy Line wharf. As passengers disembarked the steamer, the crew of the ship began to make it ready for the next voyage. One member of the crew in charge of preparing the staterooms on the ship's saloon deck was shocked to find a dead man in his bed.

The Providence police were called, the murder scene was examined and an investigation began. The body of the deceased had been shot at close range, most likely while he was asleep. The police determined the victim was John Hart, a young man who had come aboard the ship alone the previous day. The police questioned several of the crew members about their recollections

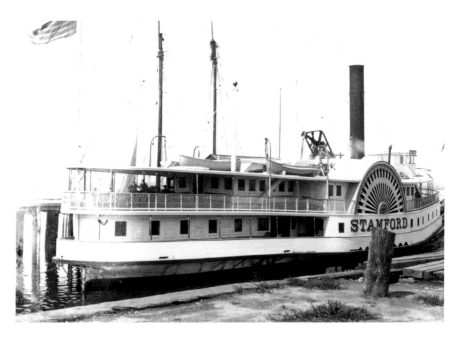

The steamer *Stanford* tied up at pier.

of seeing the young man during the voyage. They determined a gentleman had befriended the young man on the afternoon of the murder, and the two had dined together. Later that evening, the two men were seen together sitting on the quarterdeck. Hart was a stationary engineer in New York who was en route to his home in Providence, Rhode Island.

The coroner reported that the man was shot through the head by a .32-caliber gun at about 2:00 a.m. on Sunday morning. No one onboard had heard the shot. The investigation was taken over by federal officials because the murder had taken place while in the Atlantic Ocean. Conclusive proof to who murdered Hart was never found. John Carey, also known as Jack Irish, employed as a piano player on the *Larchmont*, was suspected of the murder. He was brought to trial in Providence, but because of the lack of evidence, his guilt could not be proven.

On May 4, the Joy Line was once again dealt bad news. The Joy Line steamer *Aransas*, while en route from Boston, was struck by a barge off Cape Cod and sunk. The accident occurred in thick fog. The collision rocked the steamer, awakening the captain and passengers. The captain of the *Aransas* quickly made his way to the pilothouse. He realized that his ship was badly damaged and would most likely sink. He then ordered

everyone to abandon ship. The lifeboats were filled and lowered into the water. The tugboat that was towing the barge that struck the *Aransas* pulled up to the sinking ship and took the passengers and crew onboard. It was later reported that thirty-six of the thirty-seven passengers onboard the *Aransas* were rescued.

Joy Line officials once again set out to purchase a ship to replace one that had been lost. In the summer of 1905, the steamer *Stillwater* was purchased from the United Fruit Company. The *Stillwater* was a steel-hulled ship built in 1883. It was purchased to sail between Boston and Philadelphia for a new route the company was planning.

The Joy Line also purchased the steamer *Georgetown* that summer. The *Georgetown* had sunk after a collision with another ship on the Delaware River. It was raised and towed to Brooklyn, New York, where it was put up for sale at a bargain price.

During the beginning of 1905, the Joy Line began deliberations over selling the company. Joy Line's biggest competitor, the New England Navigation Company, a division of the New Haven Railroad, made an offer.

After many days of deliberation by both sides, the Joy Line agreed to sell the company for the price of $775,000. The decision to sell was a difficult one. The company had just begun to see profitability and had an

Boats tied up along a pier.

understanding of what it took to operate as a successful steamship line. The agreement stipulated that the Joy Line would continue to operate as it had in the past, with the same management and personnel.

1906

The company, now under new ownership and with an ample amount of capital, created an atmosphere of success among the Joy Line officials. It also had the ability to run the day-to-day operations in a less stressful environment than it had in the past. The company no longer needed to spend a vast amount of time trying to stay one step ahead of its biggest competitor. The Joy Line received orders and support in the early months of 1906 to expand its operations. Competition still existed with other steamship lines. The New Haven Railroad used its new company as a tool to further its business interests.

Many changes took place early in 1906, with some ships of the Joy Line sold off and many newer ships purchased. Some changes in routes and arrival and departure times were also made in an effort to better serve the traveling public and the company's freight customers. The first ship to be purchased by the new Joy Line was the *Tennessee*. It was built in 1898 for the Old Bay Line and was 245 feet long and 38 feet wide and weighed 1,240 gross tons. The Joy Line put their new steamer to work on a newly established route between New York and Fall River.

The steamer *Martinique* was also purchased a few weeks later. It was to be used on the Fall River route, running alongside the *Tennessee*. The New England Steamship Company of Bath, Maine, built the *Martinique* in 1897. It was 203 feet long, 36 feet wide and weighed 997 gross tons.

After its arrival at the Joy Line wharf, the steamer *Martinique* made one trip for the company and then was sent to be overhauled in New York. Within a few weeks, the work was finished and the *Martinique* was renamed the *Kentucky*. It sailed from New York to Fall River to begin its service for the company on the New York and Fall River route. It would run six days a week, at a cost to passengers of one dollar. This cheap fare attracted many new customers.

Now, with its new route between New York and Fall River established, the Joy Line began working on another new route between New York, New York, and Bridgeport, Connecticut. The steamer *Richard Borden*

Passengers departing a steamer.

was purchased and sailed to New York for a complete overhaul. Once finished, it was renamed the *Fairfield* and began a regular schedule on the new Joy Line route between New York, New York, and Bridgeport, Connecticut.

In the summer of 1906, George McVay, who was working onboard the steamer *Larchmont* under Captain David Wilcox, was promoted to captain. The position of captain of the *Larchmont* came open after Captain Wilcox was given the position of captain on the steamer *Tennessee*. Captain George McVay was only twenty-five years of age at the time but was thought of very highly after his heroic actions aboard the steamer *Tremont* when it had caught fire and sunk in New York Harbor.

1907

The year began with optimism. The company had expanded its fleet, adding several new steamers and starting new routes of service. The transition in the way the company operated under its new ownership went smoothly. The

Gentleman standing amidships.

Joy Line now received its orders from the railroad that used the company to all but monopolize transportation along the New England coast.

The month of January passed without any major incidents, but February 1907 would be quite different. On Sunday, February 10, the steamer *Larchmont* returned to Providence in the early morning hours. It stayed tied up at the Joy Line pier overnight where it was prepared for its next scheduled trip the next day.

While in Providence, many of the crew, including Captain McVay, left the ship for their homes, returning the next day. The weather on that Sunday was severe, with near blizzard conditions.

On Monday, when the captain and crew began arriving back at the ship, the weather began to improve, but the wind still blew heavy and the temperature remained below freezing. Passengers began arriving as early as 3:30 p.m., boarding the *Larchmont* for the trip to New York. The scheduled departure time was 6:30 p.m. Shortly before 6:00 p.m., the snow that had been falling lightly began coming down heavily. As the next half hour wore on, the snow stopped.

Captain McVay made the decision to delay departure till 6:45 p.m. to see if the weather would continue to improve. At 6:55 p.m., the captain gave the order to cast off. He felt the conditions had improved enough to depart. The temperature, however, was just a few degrees above zero. The night was very dark as the *Larchmont* slowly made its way from the pier and paddled down the Providence River. As the *Larchmont* left the west channel and headed out into the open ocean, the wind increased and heavy waves rocked the ship.

As the Watch Hill Light came into sight off in the distance on the starboard side of the ship, the crew spotted a steamer way off in the distance. It was presumed to be the steamer *Tennessee* that was seen earlier coming out of the east channel. Shortly after, the crew spotted the dim light of a schooner. The pilot of the *Larchmont* monitored the now-visible red and green lights of the approaching schooner and gave orders to turn the steamer to starboard. The high winds hampered the turning of the large ship and pushed the approaching schooner along at high speed. Within moments, the two vessels collided, and the tragedy played out.

THE STEAMER *LARCHMONT*

Constructed in Bath, Maine, in 1885, the *Larchmont*, originally called the *Cumberland*, was then operated by the International Steamship Company.

Throughout its operation, it was regarded as one of the finest side-wheel steamers of the day, being strongly built with excellent passenger accommodations. From 1885 to 1900, the *Cumberland* and its sister ship the *State of Maine* operated along the coast of Maine. Both ships were built with two tall smoke stacks and walking beam engines. In later years, the *Cumberland's* two stacks were changed to one.

The *Cumberland*, from its conception, took on a reputation as a hard luck ship. Many misfortunes befell the vessel and crew. On Monday, July 7, 1902, the *Cumberland*, returning from a day trip to Portland, was struck on the starboard bow by the United Fruit liner *Admiral Farragut* just outside Boston Harbor. The violent collision did considerable damage. Captain Allen of the *Cumberland* had to make a decision to either wait for help (and possibly sink before all the passengers could be safely disembark) or make a dash for land and avoid a total loss. Captain Allen gave the order to proceed into the harbor, making it back to the wharf.

After tying up, the passengers were quickly unloaded. The ship was taking on water at a steady rate, but the decision was made to tow it to a repair yard in east Boston. While being towed by two tugboats, the *Cumberland's* luck ran out. The rate of water pouring into the *Cumberland* increased, and when the bow of the ship became submerged, it became apparent that it would

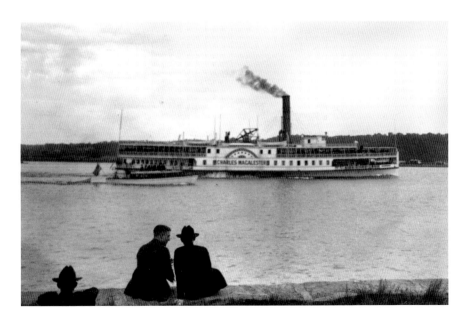

The steamer *Charles Macalester* of the Mount Vernon and Marshall Hall Steamboat Company.

not make it to the repair yard. The tugs then pushed the ship onto the mud flats in Boston Harbor. For the next few days, the *Cumberland* lay aground while temporary repairs were made. It was then raised and taken to McKie's Shipyard. The estimated repair cost was in excess of $60,000. The Eastern Steamship Company made the painful decision to retire the ship, turning it over to the company that insured it at the time of the collision.

In August 1902, Charles L. Dimon of the Joy Line purchased the *Cumberland* "as is" for $60,000 from the insurance adjusters shortly after the Eastern Steamship Company decided to retire it. The necessary repairs were made, and the Joy Line soon realized what a good investment it had made. It was at this time that the *Cumberland* was renamed the *Larchmont* and became part of the Joy Line fleet.

During 1903, the *Larchmont* ran between New York and Providence six days a week. Also running the route was its sister ship the *Tremont* of the Joy Line. With the ever-growing competition from other shipping lines at that time, the company implemented many changes to routes, pricing and company policy in order to stay profitable.

This tenuous struggle brought company officials to the decision in December 1905 to transfer operations of the Joy Steamship Company to its rival, the New Haven Railroad, which then monopolized the shipping and transportation business in New England.

6

OTHER DISASTERS

From New England's beginning to the present day, sea travel has never been without risk. Safety measures enacted and enforced by governmental agencies, no matter how stringent, cannot prevent tragic events from occurring. In no time has this been more evident than at the beginning of commercial steam travel. In no place has it been more apparent than along the coast of New England.

The *Larchmont* disaster, clearly one of the worst, was only one instance of what could go wrong at sea. Several other such disasters along the coasts of Rhode Island, Massachusetts and Connecticut occurred during this time, many of which could have been prevented. With each disaster came changes in regulation and safety standards in an effort to make sea travel safer.

Ocean traffic during the mid- to late nineteenth century off the coast of New England was heavy, and the probability of a collision between two vessels was high. During this period, several steamship companies, with their numerous ships, transported a vast number of passengers along New England's coast daily. A few of these companies demonstrated a commitment to passenger safety, whereas others showed less concern.

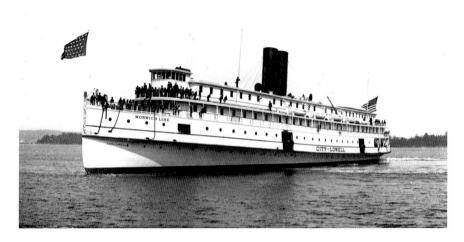

The steamer *City of Lowell* of the Norwich Line.

METIS

Off the shore at Watch Hill, a disaster unfolded on the night of August 30, 1872. The steamship *Metis* had departed New York City around 5:15 p.m. on August 29, 1872, en route to Providence, Rhode Island. In New York it had taken on cargo and 146 passengers in addition to its crew of forty. Proceeding through Long Island Sound, the *Metis* encountered rough seas and heavy rain. At 3:30 a.m., as the *Metis* was some four miles south of Watch Hill, a member of the crew noticed the lights of the schooner *Nettie Cushing*.

The weather grew worse, and the visibility became poor. The crew of the *Metis* kept their course as best they could, but within minutes, they noticed that the schooner had changed its course. Unable to maneuver quickly enough to avoid an accident, the schooner collided with the *Metis* on its port side. Onboard the *Metis*, Captain Charles L. Burton ordered crew members to go below deck and bring back a damage report. While waiting, the captain asked his crew to also see if anyone on the schooner *Nettie Cushing* was injured.

Onboard the *Nettie Cushing*, the damage to the bow was extensive, but after a quick assessment, the captain and crew believed the vessel seaworthy, and the order was given to set a course and proceed to New London, Connecticut. Confusion onboard the *Metis* after the collision made it difficult for the crew to accurately assess the true damage and condition of the ship. At 3:45 a.m., fifteen minutes after the collision, the engineer rushed from

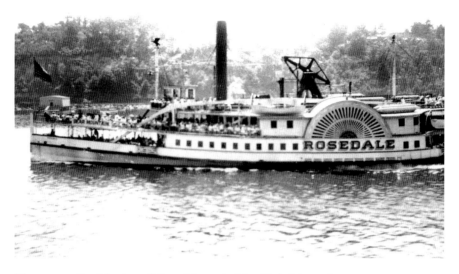

The steamer *Rosedale* taken off Bear Mountain, New York, July 4, 1912.

below and entered the pilothouse, warning that the ship was leaking badly. Ocean water quickly flooded the engine room, flooding the boilers with water and stopping all movement of the ship. On hearing the news, the captain ordered the ship to head in the direction of Watch Hill in an attempt to run his ship aground before it sank.

The captain gave orders to the stewards to wake any of the passengers who were not already aware of the situation. The stewards found the quickest way to do this was to break out the stateroom windows. Miles from shore, the captain ordered life preservers to be handed out and the steamer's lifeboats to be filled and launched.

The crew, in their attempt to launch the three lifeboats as quickly as possible, lost control of one and smashed it against the side of the ship. Many of the passengers and crew members who were not able to secure a spot in one of the lifeboats proceeded to the upper deck in an effort to stay higher than the water level. The severe weather quickly took a toll on the ship, and within minutes, large waves began crashing against the upper deck, detaching it from the ship. Those in the lifeboats recalled the dreadful scene, seeing many clinging to the deck, screaming for help, some losing their grip and being swept off into the ocean. As the lifeboats launched, the ship shuddered severely and went down. The strong vortex from this carried thirty to forty people down with the ship.

Word of the disaster spread quickly, and at Watch Hill, hundreds had gathered along the shore, some viewing the scene through glasses and others with the naked eye. From Watch Hill, word of the disaster was sent to Stonington, Connecticut, where the United States revenue cutter *Moccasin* set out to aid those in need. The *Moccasin* quickly reached the scene and noted no sign of the steamers; however, much debris from the disaster floated about. Also floating in the massive debris were large bales of cotton, which looked a lot like small icebergs.

The upper deck that had detached had broken into pieces. On many of these pieces clung many of the passengers and crew of the *Metis*. The *Moccasin* launched its lifeboats and began picking up survivors, many of whom seemed more dead than alive. The strong wind and high seas made their rescue attempts difficult. The rescuers that night from the *Moccasin* picked twenty-six survivors from the water, some of whom needed to be resuscitated. They also picked up fourteen dead. Several of the officers and crew from the *Moccasin* were later awarded the Medal of Honor from the United States Congress for their heroic service in saving lives that night.

Shortly after sunrise at Watch Hill, many townspeople gathered along the shore, ready to give assistance to anyone in need. Offshore, the schooner *A.B. Belden* pulled two bodies from the ocean, both of them wearing life preservers with the name *Metis* printed on them. Several volunteers from the lifesaving service, as well as several fishermen, launched two rowboats out into the surf in an effort to rescue those coming ashore. At 8:15 a.m., pushed along by the strong winds and heavy waves, the upper deck of the *Metis* came ashore at Watch Hill.

Some of the rescuers on the beach that morning recalled the unusual scene of miles of rainbow-colored ribbon, cargo from the ship, dislodged from its boxes and unwound by the waves. Also noted were hundreds of tins of tobacco that had washed up in the surf. Many of these tins opened, and the contents spilled out and were described as looking like dark seaweed. The empty cans made a chilling clanging noise as they struck one another. Some of the rescuers described seeing large white bales of cotton with people clinging to them. These cotton bales were propelled quickly ashore by the heavy waves. Along the shore, thirty-two lives were saved in a heroic effort by those gathered that morning. The bodies of those recovered were transported to a hall in North Stonington, Connecticut, where viewing and identification by family and friends was carried out.

The official passenger list of those onboard the *Metis* that night was lost when the ship went down. The crew of the *Metis* only gave an estimate of

Providence and Fall River Steamship Line.

the number of passengers onboard that night; many believe the number of those who perished that night was much higher. The final estimate of those who lost their lives was fifty men, women and children. The news of the horrific accident quickly spread and became national news, reported in many papers across the country.

For many days after the disaster, wreckage from the *Metis* washed ashore. Many sightseers and souvenir hunters walked the beach in search of something from that night. Many noted timber and other large pieces from the *Metis* that came ashore and quickly became embedded in the shifting sands. Some would approach these sand-covered mounds and gently remove the sand, believing a victim of the disaster might lie beneath.

Many survivors had their own vivid stories to tell of how they survived that night, which were printed in great detail. For many years after the disaster, people visiting and vacationing at Watch Hill, Rhode Island, would be told in graphic detail of that night and the days that followed by residents and staff from the many locals hotels that witnessed the tragedy. Some forty years after the sinking, artifacts from the *Metis* could still be found displayed at several hotels. At the Colonial, a segment of the steering wheel of the *Metis* was hung in the lobby. At the bathing beach by the Larkin House stood

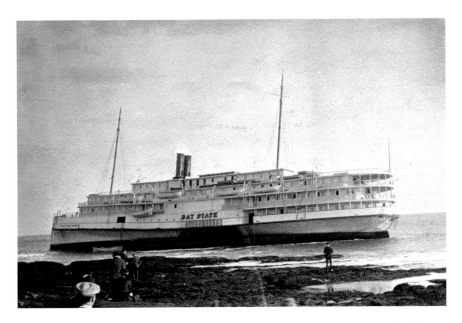

The wreck of the steamer *Bay State* at the entrance to Portland Harbor, September 23, 1916.

an icebox from the *Metis*. A passenger who survived that night had used the icebox as a lifeboat.

The *Metis* was built in New York, New York, in 1864. The hull was constructed primarily of wood, and the ship was powered by steam. The overall length of the ship was two hundred feet, with a sixteen-foot draft. It weighed in at 1,238 tons. At the time of the collision, it was owned and operated by the Providence and New York Steamship Company.

NARRAGANSETT

One of New England's worst maritime disasters occurred on June 11, 1880. The steamer *Narragansett*, traveling through the mouth of the Connecticut River at around 11:30 p.m., collided with its sister ship the *Stonington* of the Stonington Line. The *Narragansett* had left the North River Pier, located at the foot of Jay Street in New York, at 5:00 p.m. with over three hundred passengers onboard. At around 10:00 p.m., the steamer *Stonington* had left the port fully loaded with passengers and freight. As it made its way down the river, exiting the dense fog at the mouth of the Connecticut River, the

pilot of the steamer *Stonington* noticed another steamer coming toward his ship at fast speed.

The pilot rang the ship's bell, signaling the engine room to stop the ship, but before any maneuvers could be made, the steamer *Narragansett* crashed directly into the side of the steamer *Stonington*. The collision was severe, causing the bow of the *Stonington* to swing around, crashing into the starboard side of the *Narragansett* and penetrating deep into the ship. As the bow of the *Stonington* had swung around, it had swept along the side of the *Narragansett*, wiping away many of the *Narragansett*'s staterooms on the upper deck. This caused the occupants inside their rooms to be thrown out onto the deck or into the ocean. Many would later describe the way the *Stonington* damaged the *Narragansett* as being crushed like an egg. After the collision, the two vessels drifted apart.

Onboard the *Stonington*, the damage was quickly assessed. The outer planking of the ship where it was struck had been ripped off below the waterline for a distance of fifteen feet. It had taken on water but was not in immediate danger of sinking.

The condition of the steamer *Narragansett* was much worse. It had a massive hole in its side where water began rushing in. This water quickly made its way to the boilers, disabling the ship and plunging the vessel into darkness. The situation went from bad to worse when a fire broke out and began to spread.

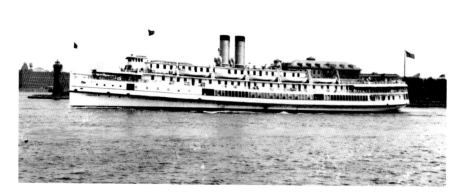

The steamer *Richard Peck* of the Meseck Line.

Most of the passengers were awakened by the collision and ran on deck to see what had happened. They soon discovered a nightmare unfolding in front of them. Many survivors would later recall seeing their fellow passengers, many of whom were scarcely dressed, grabbing life preservers and jumping headlong into the ocean.

Soon after the collision, both the steamer *Narragansett* and the steamer *Stonington* began launching the lifeboats, but people soon realized that these boats were useless because the plugs used to let rainwater leak out had not been reinstalled and could not be found. Also, the oars used to propel these boats were missing. The steamer *City of New York* that was en route to New York spotted the crippled steamer *Narragansett*. Noting the quick-moving fire on the deck of the *Narragansett*, the crew of the steamer *City of New York* quickly dispatched its lifeboats and was able to rescue many from the doomed steamer. The steamer *Narragansett* became fully ablaze, burning to the waterline and sinking within half an hour after the collision. The total number of those who lost their lives after the collision was never accurately determined.

LEXINGTON

The steamship *Lexington*, while en route to Stonington, Connecticut, had caught fire and sank. The *Lexington* left New York at 3:00 p.m. on January 13, 1840, with over 140 passengers onboard. It was also carrying 150 bales of cotton and other miscellaneous freight. The weather that day was cold, and the temperature had fallen to near zero in the late afternoon. The wind was blowing heavy, making navigation difficult. At around 7:30 p.m., the *Lexington* was about four miles offshore of Eaton's Neck on the north shore of Long Island when a fire was noticed in the area of the ship's smokestack.

The crew attempted to extinguish the flames using buckets of water and a small hand pump, but their efforts were unsuccessful. The ship's captain that day was George Child. He was filling in for captain Jacob Vanderbilt who was the *Lexington*'s usual captain, but due to an illness, Vanderbilt could not operate the ship that day. As the effort to extinguish the fire was unsuccessful, the captain ordered the three lifeboats of the *Lexington* to be prepared for launch.

The passengers, noting that the fire was beginning to spread, panicked. The pilot of the *Lexington*, Stephen Manchester, realizing the situation,

headed the ship toward shore in an effort to beach it. The fire quickly spread below deck, and the crew tried to reach the engine room to disengage the boilers so that the lifeboats could be launched safely. Unable to reach the engine room because of the thick smoke, the order was reluctantly given to lower the first lifeboat. Captain Childs, who was assisting the passengers, had fallen into the lifeboat just prior to its launch. As it hit the water, the lifeboat was quickly sucked into the ship's paddlewheel, which was turning at full speed. The lifeboat was torn to pieces, and its occupants were killed. The two other lifeboats were lowered, but because of the incorrect rope length used to lower the boats, they hit the water hard, which caused them to sink. As the pilot steered the *Lexington* toward shore, the fire below had reached the drive ropes used to control the rudder, burning through them and leaving the pilot unable to control the ship.

A short time after this, the fire had disabled the engines, and the ship began to drift away from land. The ship, now two miles from shore, was at the mercy of the wind. The heavy black smoke from the fire was intensified by the strong wind and restricted the passengers' movements. Those in the vicinity of the cotton bales began to push them over the side of the ship and attempted to use them as rafts. Soon after, many who saw no escape from the flames began jumping over the side and climbing onto the cotton bales as they bobbed up and down on the waves. Other passengers began throwing wooden boxes that were on deck into the ocean and then jumping into them too.

One of the four who survived that night recalled in an interview later that he helped crew members push bales of cotton over the side in an effort to

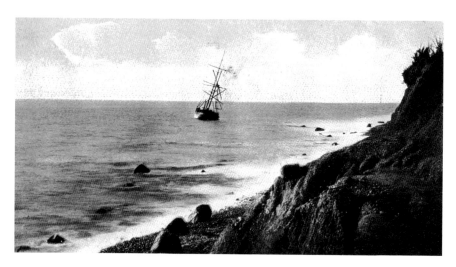

A shipwreck off of Block Island.

give those in the water something to cling onto. Chester Hilliard, who was twenty-four years of age, survived by climbing onto a bale of cotton just prior to 8:00 a.m. when the main deck collapsed. Benjamin Cox, a crew member, also climbed onto the cotton bale with Hilliard and floated for about eight hours on the bale in the frigid weather. Cox, overcome by the cold, fell off the bale into the icy water and drowned. A crew member from the sloop *Merchant* spotted Hilliard on the bail, and he was pulled to safety.

The description of the scene onboard the *Lexington* by those who survived was beyond imagination. They would recall that the fire broke out mid-ship, and the flames and smoke quickly cut off communication from one end of the ship to the other. The panicked passengers and crew gathered at both the bow and stern, some praying and others crying to be saved. Many began jumping overboard to escape the flames.

The ship, while still ablaze, slipped beneath the waves and sank at 3:00 a.m. In the investigation that followed, it was found that the *Lexington* had been determined unseaworthy and condemned a few months prior. The company that owned the ship thought otherwise and had kept the *Lexington* in service. The investigation also revealed that the *Lexington* had a fatal flaw in its design, and this was believed to be the cause of the fire. When built, the *Lexington*'s boilers were designed to burn wood. They were later converted to burn coal in 1839. The work done at this time was incomplete, leaving the

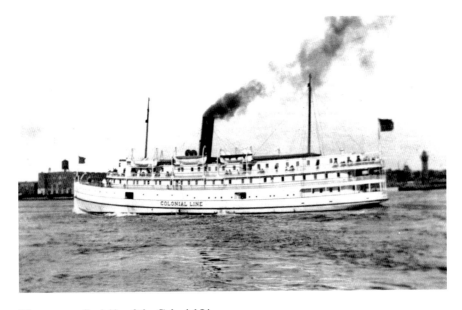

The steamer *Cambridge* of the Colonial Line.

boilers in an unsafe condition. The faulty boilers had caused several other small fires on prior trips; those, however, were quickly extinguished. Even after these fires, repairs were not carried out to fix the problem.

There was another ship in the area at the time the *Lexington* caught fire that could have given aid and saved lives. The sloop *Improvement* came within five miles of the *Lexington* at the time it was ablaze. The captain of the sloop, William Tirrell, was asked why he did not offer assistance to those on the burning ship. He explained that because of his schedule, he could not aid in the rescue because he would miss the high tide. He was later painted as a villain in the press for his actions.

In 1842, an effort was made to raise the *Lexington*. The vessel was successfully raised from the ocean floor for a short period. Thirty pounds of silver that had been aboard the *Lexington* when it went down was recovered. The silver had been melted into a mass by the flames. Shortly after, the chains used to bring the vessel to the surface broke, sending the ship back to the ocean floor. Bishop and Simonson in New York built the *Lexington* in 1834 for Cornelius Vanderbilt. It was 207 feet from stem to stern and 40 feet from side to side. It was constructed using the best materials, regardless of cost.

PORTLAND

One of New England's greatest disasters occurred when the passenger steamer *Portland* was lost in a hurricane in 1898. The *Portland* left the India Wharf in Boston en route to Portland, Maine, on November 27, 1898; an estimated 190 passengers and crew were onboard. The *Portland* was also carrying a variety of cargo, including furniture and canned goods. Also onboard was an estimated one ton of gold and other valuables.

Many aboard were from Maine, returning from the Thanksgiving holiday spent with relatives in the Boston area. At 7:00 p.m., the *Portland* pushed off from its wharf and began its trip down the harbor. Some would later question why Hollis H. Blanchard, the captain of the *Portland*, did not stay in port until 9:00 p.m. to get a better understanding of the weather conditions. At 5:30 p.m., officials of the steamship company that operated the *Portland* had left orders that the vessel should stay in port until 9:00 p.m. to assess weather conditions. Some believe the captain never received word of this and made a decision to leave Boston, hoping the weather would improve.

As the *Portland* passed out of Boston Harbor into the open ocean, it was sighted by the keeper of the Deer Island Light. The *Portland* passed the vessel *Kennebec*, which was going in the opposite direction. The *Kennebec* was heading into the harbor to take refuge from the oncoming storm. Also passing the *Portland* was the steamer *Mt. Desert*, which was heading into Boston Harbor to ride out the storm. The captain of the *Mt. Desert* believed it unusual to see the *Portland* heading out to sea in such potentially dangerous weather. Many aboard the *Mt. Desert* believed the *Portland* would turn about and were surprised that it did not, instead continuing on its way out to sea.

The weather was worsening, with the wind blowing from the northeast and a light snow beginning to fall. Another sighting of the *Portland* was made at 9:30 p.m. by the schooner *Maude S.* The schooner was off Bass Rocks, a few miles southwest of Thatcher's Island, heading for Gloucester Harbor. The lookout on the schooner saw the faint lights from the *Portland* going in the opposite direction.

The visibility was limited due to the snow. The two vessels passed each other, with the schooner heading for a safe harbor and the steamer heading out to sea. A few hours after the sighting by the schooner *Maude S.*, the *Portland* was seen by Captain Reuben Cameron of the schooner *Grayling*. He later told officials that around 11:00 p.m. he came close to the *Portland* about twelve miles south east of Thatcher's Island. The weather was severe, and visibility was poor.

The lookout of the schooner *Grayling* spotted the *Portland* heading straight for them. Orders were given to light a flare in hopes the lookout of the *Portland* would see them. The *Portland*, sighting the schooner, turned, and both vessels passed each other in proximity. Those on the schooner clearly identified the steamer as the *Portland*, noting it struggling along in the turning ocean.

Two other sightings of the *Portland* were later reported. The *Portland* was sighted at 11:15 p.m. by the schooner *Florence E. Stearn* and again at 11:45 p.m. by the schooner *Edgar Randal*. Captain D.J. Pellier of the *Edgar Randal* reported that, while fourteen miles off the eastern point of Gloucester, they spotted a damaged steamer, believed to be the *Portland*, heading in a westerly direction. The steamer was running without lights, and its superstructure was badly damaged.

This was the last sighting that night of the *Portland*. The fate of the *Portland* after this last sighting can only be speculated. Judging by the last account at 11:45 p.m., the *Portland* was badly damaged. It is believed that prior to this sighting, the *Portland*'s engines briefly stopped for some reason, leaving the ship uncontrollable and vulnerable to being turned broadside, and then

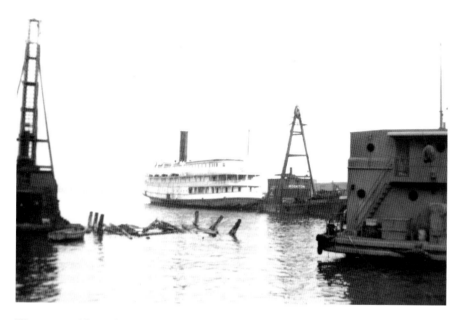

The steamer *Meteor* of the Colonial Line.

damaged by the mountainous waves of that night. It is believed that the engines later again became disabled, leaving the vessel at the mercy of the violent weather, eventually sinking the *Portland*. As for the passengers, the constant churning of the ocean and the smashing of the waves on the ship must have blanketed them in terror.

At daylight, the weather improved slightly, but visibility remained bad. The schooner *Ruth M. Martin* was sailing several miles off Highland Light when it spotted the *Portland* off in the distance; the steamer *Pentagoet* was also sighted. Neither vessel was ever seen again.

At 7:00 p.m., a crew member of the Race Point Life-Saving Station, while on beach patrol, came across a life preserver lying on the beach. The life preserver had the name *Portland* printed on it. Shortly after this, a crew member from the Highland Light Life-Saving Station came across the first body from the *Portland*, floating in the icy surf at North Truro. All during the day, bodies and wreckage from the *Portland* washed ashore.

That morning in Portland, Maine, many waited at the pier for the arrival of the *Portland*. Due to the storm, all the telephone lines were blown down and communication between Boston and Maine was cut off. Family and friends of those onboard the *Portland* did not receive word of the ship's fate

People bathing at the beach with a schooner off in the distance.

until days later. A total of thirty-five bodies were retrieved from the ocean, with the last one found on December 6, 1898.

In the investigation that followed, the *Portland*'s captain and the company that owned the *Portland* was found not to blame for the ship's sinking, and it was ruled an "act of God."

The *Portland* was built in 1889, in Bath, Maine. It was 281 feet long and 42 feet wide. The hull was constructed of wood, and it weighed 2,284 tons.

CITY OF COLUMBUS

One of New England's worst maritime disasters was the running aground of the steamer *City of Columbus*, with a loss of life of 103 passengers and crew.

En route to Savannah from Boston, in the early morning hours of January 18, 1884, the passenger steamer *City of Columbus* ran aground on the rocks of Devils Bridge, near Gay Head Lighthouse in Massachusetts. At 3:45 a.m., while off Martha's Vineyard, the lookout of the *City of Columbus* spotted the Devils Bridge buoy off the port side of the ship. Realizing the buoy should be on the starboard side, he reported this to the pilothouse. Shortly after, the ship struck a ledge submerged below the

waterline. Captain Wright of the *City of Columbus* immediately ordered the ship to steer to hard port.

The weather was stormy with a gale blowing steadily, but the visibility was good and the moon could be seen clearly through the cloudless sky. Shortly after the ship was turned to port, it again struck the reef. The captain and crew made several attempts to free the ship from the reef. An order was then given to reverse the ship in an attempt to free it from the jagged rocks. The ship successfully pulled away; however, the icy cold ocean began pouring into the vessel. Captain Wright went below deck to inform the passengers of the situation. Soon, the cold sea rushed in, forcing them to flee to the top deck.

As they gathered once again on deck, an enormous wave hit the ship, washing all those assembled into the icy ocean. Many of those now in the frigid water tried to stay afloat as raging waves crashed over them. Many were able to grab on to the rigging of the ship that had broken free and lay in the water. Lifeboats were launched from the ship, but because of the heavy waves, they smashed into the side of the ship, making them unseaworthy. A rescue party from the mainland rescued some of the people who were able to hold on in the icy water. Out of the 132 passengers and crew onboard, only 29 were rescued.

The *City of Columbus* was built in 1878. It was 275 feet in length and weighed 2,200 tons.

7

POPULAR DESTINATIONS

In the mid-nineteenth century, New England became a choice vacation destination. Many locations along the coastline quickly realized the value of tourism to their communities. These communities began building infrastructure to accommodate the vacationing public. Many individuals and families that lived inland made the trip to the coast by rail and ship to enjoy the beaches and other attractions along the coast.

In Rhode Island, four communities stood supreme as a place for the ever-increasing vacationing public to spend their leisure time. Block Island, Watch Hill, Newport and Narragansett became the prime destination choices for many. Each of the four had its own unique character and features. These destinations attracted a spectrum of travelers seeking a retreat from everyday life.

Improvements in transportation and affordability compelled those who previously could not afford to vacation in such places to do so. For the communities that encouraged and accommodated the vacationing public, new areas of business flourished and with them came employment for the local population.

Steamship travel during this period thrived, and many travelers utilized some popular ports such as Stonington, Norwich and New London in Connecticut, as well as the Providence and Newport ports in Rhode Island. Many aspects—such as breathtaking ocean views, cool ocean breeze, pristine sandy beaches or seaside activities—attracted those seeking a respite.

Posing for a photo on the beach.

The elegant architecture of the numerous resorts sprinkled throughout these destinations left enduring memories within the minds of vacationers. These grand hotels constructed during the Gilded Age, with their myriad amenities, compelled patrons to return year after year. Many of these seaside summer resorts began their existence with modest means. Expansion and development created a unique individuality for these glamorous hotels.

Watch Hill grew to be one of Rhode Island's most beautiful Victorian seaside destinations. Several of Watch Hill's most prominent resorts were Watch Hill House, Larkin House, Plimpton and Ocean House. Vacationers came to Watch Hill to spend their time on the well-kept beaches and shop

in the many stores. Other locations such as Fort Mansfield and Watch Hill Light were also popular points of interest.

Block Island's isolated location and inherent natural amenities attracted many looking for a secluded retreat from everyday life. Several prominent resorts were established to accommodate the ever-increasing number of those coming from the mainland. The Ocean View Hotel and the Spring House where two prime examples of the elegant Victorian resorts built on the island.

Newport became the prime vacation destination for those with wealth and those seeking the many activities that this beautiful destination had to offer. Newport was one of the first to emerge in New England as a place to vacation along the coast. Enhancing the coastline of Newport are many summer homes built by some of the nation's wealthiest families. These so-called cottages are some of the nation's most magnificent gilded mansions. A few of these grand palaces, such as the Breakers and the Elms, have become synonymous with the Gilded Age.

The grand architecture of these massive homes displayed the craftsmanship of the artisans employed in building them. Newport's long and lustrous history in New England sets it apart from other vacationing destinations. Visitors enjoy the history of Newport and its older buildings

The steamer *Webtchebter* of the Meseck Line.

that show the charm of colonial times. In town, the hustle and bustle of activity drew many to the numerous shops, which provided a variety of items not seen elsewhere. Within scenic Newport Harbor, vessels of all shapes and sizes moved about majestically and were admired by those enjoying their time there.

Narragansett, with it splendid beaches and ample resorts, became well known throughout New England as a prime vacation destination during the Gilded Age. Narragansett Pier, along with the Narragansett Pier Casino, drew the prominent and wealthy, offering travelers a wide range of activities, making a pleasurable and memorable retreat from everyday life.

Along Narragansett Pier, resorts such as the Atlantic House, the Atwood House and the Gladstone Hotel provided accommodations for the vacationers seeking a restful stay along the shore. Many resorts offered not only wonderful accommodations but also a grand dining experience. Several resorts built bathhouses and other amenities for their patrons. A pier jutting out from the coastline accommodated crowds of visitors. Steamers utilized the pier and scheduled frequent stops for the loading and unloading of passengers and freight. Most of the visitors chose to travel by rail because it was a less expensive and faster mode of travel.

BLOCK ISLAND

The town of New Shoreham, better known as Block Island, is a small island in the Atlantic Ocean, located twenty miles southwest of Newport and eighteen miles northeast of Montauk Point, Long Island, New York. The island has a length of about seven miles and a width of about three miles at its widest point; on maps, it looks much like a pear. The island has a long, rich history. Its ten square miles have a variety of beautiful, scenic attributes.

The island's topography—with its rolling terrain, towering coastal bluffs and the Great Salt Pond—make a beautiful background for the wonderful diversity of architecture of the many buildings sprinkled about the island.

A mixture of Queen Ann, Victorian, Gothic Revival, Second Empire and other styles of architecture can be seen throughout the island. The popularity of architectural styles at specific periods of time are reflected in some of the grander hotels. As one architectural style went out of fashion, another would become popular. This diversity of architecture was very pleasing to the eye. Usually, the large hotels that were built prior

A beach scene in Block Island, Rhode Island.

to and during the Gilded Age used a combination of styles that inspired their patrons.

When the large hotels were built, craftsman of all types were needed. Local builders on the island were sought out, but because of the scale of these projects, builders from the mainland were brought in. Many of these were well trained in their crafts and added elements of their skill to the hotels and other structures on the island. Building materials were brought to the island by schooner or steamboat, making building on the island more difficult than building on the mainland.

Defining the character of this small island is its maritime atmosphere, with its seafaring features set against a rural coastal background. The numerous ponds of all shapes and sizes scattered across the island complement the island's rustic appeal.

Old Harbor is located on the east side of the island. Serving as the main port for passenger ferries since 1874, Old Harbor is one of the busiest locations on the island. Prior to improvements making Old Harbor an effective and useful port, Pole Harbor served the residents and fishermen of the island in its early years. After a strong gale in 1815 that devastated small piers on the southeast corner of the island in Harbor Bay, timber poles were sunk into the sandy coast on the island's southeast side.

Prior to the construction of Old Harbor, passengers traveling by steamboat or sail to the island would need to be loaded into rowboats just off shore of the island and transported to the shore, making this an undesirable way to travel for many. Completion of Old Harbor brought a renewed life to the economy of the island.

A steamer at Coney Island Wharf.

After improvements to the port at Old Harbor were made, visiting traffic to the island increased dramatically. To accommodate this influx, large resorts were built. The largest of the island's hotels was built directly across from Old Harbor. This grand hotel, called the Ocean View Hotel, began its service in the spring of 1874. The hotel was constructed with the latest modern conveniences. It was equipped with gas lighting, a billiard room, a barbershop and parlors. The large rooms of the hotel were well furnished. Catering to those visiting the island who were looking for the best accommodations, the Ocean View Hotel became the most popular resort on the island. Within a few years of opening, the hotel's popularity exceeded its ability to accommodate the rising number of visitors, and in 1877 (then again in 1883), large additions were added to the hotel. One of the additions was a large dining hall. The seventy-two- by eighty-four-foot dining hall was built to accommodate the hotel's five-hundred-guest capacity, also added was a music hall and drawing room.

The Spring House, built in 1852, was a popular destination for many vacationing on the island. The hotel's name came from the location of springs that were in proximity to the motel.

The Manisses, previously known as the United States Hotel, was located about five hundred feet from the Ocean View Hotel. The hotel was renovated in 1882, and modern amenities were added to accommodate the increase in visitors to the hotel.

The Connecticut House was constructed in 1878 on high ground close to the main road. The hotel was beautifully furnished and had a pleasant atmosphere that made patrons feel at home. The Hotel Neptune, constructed in 1882, was close by and was also well furnished and well staffed. Located between the landing and the Connecticut House was a hotel called the Woonsocket House.

Built in 1884 and having one of the best views of the ocean was the hotel called the Seaside House. Many visitors to the island would choose a hotel with an ocean view and direct access to the beach, and this made the Seaside House a popular choice. Another large resort that began service in 1883 was the Block Island House. It was known for its fine service and accommodations. That same year, a hotel called the Union House was built, and the Central Hotel, another popular spot on the island, made extensive renovations to accommodate its guests. Many other resorts were built or underwent renovations during this period. It was a testament to the island's reputation as a place to vacation and enjoy nature's beauty. Many vacationers became accustomed to staying at particular resorts each year that accommodated their specific needs and price range. The many resorts depended on the patronage of their guests for their continued economic growth.

In addition to the many hotels that were built to accommodate the vacationing public, boardinghouses on the island became widely used

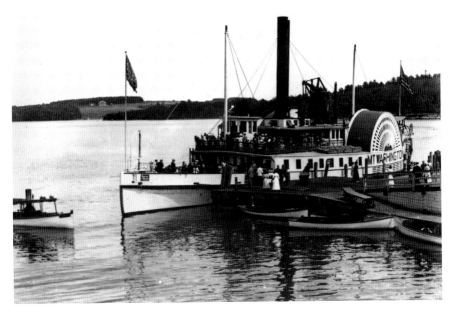

Passengers boarding the steamer *Mt. Washington*.

by the seasonal visitors and provided a necessary alternative to the hotel. In the beginning of the 1880s, many of the preexisting boardinghouses were expanded and modified to keep up with the increasing demand for reasonably priced lodgings. Many boardinghouses were also built during this time. Many visitors chose boardinghouses over hotels for their affordability and wide range of accommodations and services offered. By 1900, there were twenty-two hotels in service on the island, and in 1914, there were an estimated twenty-three boardinghouses in use.

Another option, preferred by many, was the vacation cottage. During the mid-1800s, many vacation cottages were constructed on the island. They were highly desirable for those seeking privacy and seclusion.

In the 1870s, after the construction of Old Harbor, the island became well advertised as a vacation destination. Newspapers, city directories and magazines were used to effectively advertise and promote the island as a secluded retreat from everyday life.

Increased maritime traffic and vessels of all sizes came and departed the island, creating some navigational problems. Several shipwrecks off the coast of the island prompted the government to take action. The United States Congress in 1829 provided funding for the island's first lighthouse, to be built at Sandy Point, located on the north end of the island. An effort began in 1872, after Old Harbor was established, to petition Congress for funding for a lighthouse to be built along the island's south bluffs. Funding was approved, and in 1875, Block Island's southeast light began operation.

WATCH HILL

Located on the extreme southwestern corner of Rhode Island in the town of Westerly is Watch Hill. This scenic, triangularly shaped neck of land is bound on the southerly side by Block Island Sound and northwesterly by Little Narragansett Bay and the Pawcatuck River. Mostly surrounded by the ocean and bay, a constant cool breeze coming off the ocean maintains a pleasant climate, with a temperature well below that of inland communities.

Much of Watch Hill's shoreline consists of gently sloping sandy beaches, and many of them are long and wide and ideal for bathing. Starting at Watch Hill is a swath of land that is about one and one-half miles long. Napatree Point (also known by many as just Napatree) is a barrier beach that extends

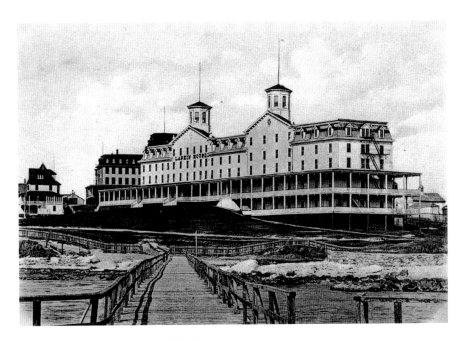

Larkin House in 1906 in Watch Hill, Rhode Island.

out into the Atlantic Ocean. The beautiful soft, white sandy beaches along Napatree continue to be used by the visitors vacationing at Watch Hill.

In the 1880s, Watch Hill had developed into a popular vacation destination with many fine resorts and summer cottages. During this period, several elegant hotels were in operation, offering a wide range of services and accommodations.

The largest of these hotels was the Larkin House, which could accommodate as many as four hundred guests. Its popularity increased each year, making it necessary for additions to be added to the main hotel in 1873, 1885, 1886 and 1888. The hotel was equipped with gas lighting throughout. The hotel was known for its well-furnished rooms and good service.

The Ocean House, built in 1868, was another large resort that would become the choice for many who came to the Hill each summer to enjoy the beautiful scenery and fine weather.

The Plimpton House was located one hundred feet from the bay; during this period, many additions were added to the original hotel to accommodate the increase of yearly visitors to the hotel. Other fine resorts operating at Watch Hill during this period were the Dickens House, built by captain Harry Dickens, the Atlantic House and the Narragansett.

Most of these large resorts had the most modern amenities found in first-class hotels of the day. The hotels at Watch Hill offered large rooms, gracious hallways and ocean views. They also had fully staffed kitchens, bakeries and pastry rooms. All of these resorts were known for fine service and fine dining. Most of the hotels had large dining rooms where a vast selection of fresh beef or freshly caught seafood was served. Several choices of seafood offered were mackerel, bass, hard and soft clams, oysters and crabs. Also offered were chicken, turkey, eggs and fresh vegetables, all grown locally.

Entertainment during the Gilded Age at Watch Hill came in many forms. One of the favorite pastimes for the young and old was taking a ride on the Flying Horse Carousel. This magnificent carousel was built around 1876 by the prominent carousel maker W.F. Dare Company of New York. The carousel was brought to Watch Hill in 1883 and was drawn by a horse. After riding on any of the twenty wooden horses, which were suspended by chains, children were left with the feeling that they had ridden a flying horse.

Bathing beaches at Watch Hill were well patronized by the vacationers and day-trippers during this period. Bathhouses were conveniently located within a short walk of many of the big hotels. Patrons could be supplied on the spot with bathing clothes, towels, etc., for a small fee.

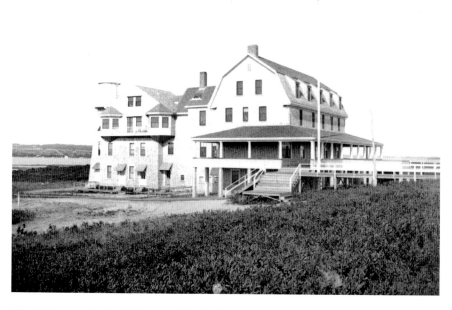

The Weekapaug Inn in Weekapaug, Rhode Island.

The lighthouse at Watch Hill is one of the area's most prominent visual features. In 1806, construction at the lighthouse began, and soon after, the light became operational. In 1856, a new, more modern lighthouse was erected at the site. In 1879, a lifesaving station was added.

Many ship disasters occurred along the coast of Watch Hill. Dense fog, shoals and numerous rocks were constant threats to seagoing vessels. A United States fort was built at the end of Napatree Point. Called Fort Mansfield and built in 1898, this fort was designed to protect the eastern entrance of Long Island Sound. The fort was part of a network of defensive forts along the coast.

NARRAGANSETT

Narragansett is a town in Rhode Island known for its charming scenery, summer recreation and beautiful beaches. Prior to 1876, those traveling to Narragansett Pier would arrive by stagecoach, which limited accessibility as a convenient vacation spot. In July 1876, the Narragansett Pier Railroad opened, making Narragansett Pier easily accessible to all. During the Gilded Age, Narragansett Pier became one of New England's most popular vacationing destinations.

Many beautiful hotels were constructed or expanded at Narragansett Pier during this period. One of these grand hotels was the Atlantic House. Built in 1866, this seventy-five-room hotel became a popular destination for many seeking a respite by the shore. A few years after opening, the hotel became so popular that it expanded, doubling in size.

The location of the Atlantic House greatly added to its success. Centrally located, the hotel was equally accessible to patrons who arrived at the railroad station or at the steamboat landing. The hotel, being situated a short distance from the ocean, provided an uninterrupted ocean breeze that was greatly appreciated during the hot summer days.

Alongside the Atlantic House was the Atwood House. Built by Joshua C. Tucker, a well-respected businessman and entrepreneur, the hotel could accommodate two hundred guests and was constructed with all the modern conveniences of the day. The hotel had a beautifully kept lawn where lawn tennis and other activities were encouraged. All the rooms at the hotel were well furnished and equipped with gas lighting.

A popular hotel built at Narragansett Pier was the Revere House. The hotel was fondly called "Rodman's" by many patrons. Captain James H. Rodman

Posing for a photo on the beach.

built it in 1854 on the corner of Ocean Avenue and Rodman Street. Being the first to construct a house at the pier for the sole purpose of renting rooms for the traveling public, Rodman was a true pioneer in establishing Narragansett Pier as a summer resort destination. The Revere House saw an increasing demand each year for accommodations by Narragansett Pier vacationers. This made it necessary to expand the hotel and add more modern conveniences.

Another grand hotel built during the Gilded Age at Narragansett Pier was the Massasoit House. Built in 1860 by Charles Maxson, the hotel was first called the Maxson House. The hotel was built far from the beach, making it somewhat undesirable to many vacationing at the pier. Under new ownership in 1877, the building was moved nearer to the beach and its name changed to the Massasoit House. Many improvements were made, and the hotel was enlarged to accommodate 140 guests. The four-story hotel had large, well-furnished rooms, many with a wonderful view of the ocean.

Opened in the summer of 1871, the Mount Hope Hotel was a splendid and well-furnished hotel built specifically to meet the needs of those looking for a quiet, restful vacation. The hotel could accommodate three hundred guests. Built with speaking tubes located in the hotels halls, guests could communicate with the hotel staff and offices.

Another notable hotel at the pier was the Narragansett House. Opened in July 1856, the hotel became a popular choice and had doubled in size by 1880. Many of those staying at the Narragansett House patronized the hotel year after year.

Many who came to Narragansett Pier quickly came to appreciate the beautiful ocean view and splendid bathing beaches. The Narragansett Beach, located to the north of the hotels, stretches over a mile. Sloping gradually to the water's edge, the fine, white sand and gently breaking surf are desirable attractions at Narragansett Pier.

A popular destination for those vacationing at the pier was the Narragansett Pier Casino. Built in the 1880s, the casino became the center for those looking for recreation and social activity. Patrons of the casino were some of America's most affluent figures during the Gilded Age. The wealthy customers could indulge themselves in a wide range of activities. The casino offered a variety of activities such as tennis, boating, billiards, cards, bowling and shooting. The casino also had restaurants, a theater, stores and a ballroom. Designed by McKim, Mead and White—the most sought after architectural firm of that time—the casino was designed with Victorian and Queen Anne–style architectural elements. Once completed, the building added a pleasing visual touch to the area. Most notable were two large towers that charmed the hearts of those vacationing at the pier. A bathing pavilion was also built, and it greatly enhanced the enjoyment of

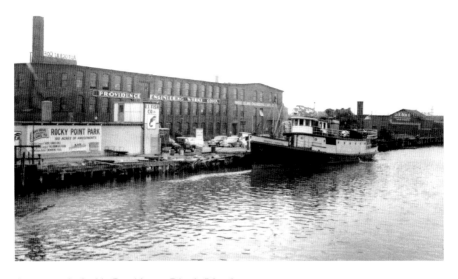

A steamer docked in Providence, Rhode Island.

all who came to enjoy a day at the beach. The pavilion was equipped with a skating and bicycle rink and many dressing rooms.

In later years, a new pier was constructed farther up the beach, which provided more convenient access for those coming and going by steamboat. Once off the steamboat, passengers would make their way down the pier to the boardwalk. Here they were greeted with the sight and opportunity to ride the Looff Carousel that adjoined the pier at the boardwalk.

Newport

During the Gilded Age, Newport, Rhode Island, was considered the "Pearl of New England" in regards to its unsurpassed opulence and accommodations as a vacationing destination.

Around 1825, the Brinley House in Newport began offering overnight accommodations to the traveling public. Success was soon realized, and within a few years, a number of other houses offered lodging. Several years after the Brinley House opened, renovations were carried out to accommodate the increase in patronage.

Newport has a long and proud maritime history. Trade and commerce in New England has its roots in Newport. Conveniently located and equipped to accommodate shipping, Newport became the catalyst for trade throughout New England. Becoming one of the leading ports in colonial times, Newport's economic growth prompted a rapid increase of the building of homes and businesses throughout the area.

The arrival of the steamboat *Firefly* in 1817 began a new age for Newport. The *Firefly* made the journey from New York to Newport in twenty-eight hours. From this grew, each year, a faster and more efficient form of travel.

By the Gilded Age, steamboat travel had become well established as a convenient and reliable way for all to travel. At this time, several steamship companies were established along New England and offered travel accommodations for passengers as well as the shipping of freight.

During the Gilded Age, many elite families throughout America came to recognize the charm of Newport and built beautiful mansions there. Many of these so-called cottages were summer homes where socializing and recreations were carried out. These picturesque mansions designed by some of America's most prominent architects and landscape designers would become the symbol of the Gilded Age throughout America.

BIBLIOGRAPHY

O ver the past several years, we gathered research material for this book consisting of news articles, books, notes and documents. The sources we used were vast and too numerous to list. Several books listed below we found beneficial.

Best, Mary Agnes. *The Town that Saved a State: Westerly*. Westerly, RI: Utter Company, 1943.

Cole, J.R. *History of Washington and Kent Counties, Rhode Island*. New York: W.W. Preston & Company, 1889.

Cram, W. Bartlett. *Picture History of New England Passenger Vessels*. Hampden Highland, ME: Burntcoat Corporation, 1980.

Dunbaugh, Edwin L. *The Era of the Joyline: A Saga of Steamboating on Long Island Sound*. Westport, CT: Greenwood Press, 1982.

Griscom, Clement A. *Fort Mansfield: Napatree Point Watch Hill, Rhode Island*. Westerly, RI: Utter Company, 1992.

Hocking, Charles, FLA. *Dictionary of Disasters at Sea During the Age of Steam*. London, UK: Lloyd's Register of Shipping, 1969.

Karentz, Varoujan. *The Life Savers: Rhode Island's Forgotten Service*. Charleston, SC: CreateSpace, 2012.

Livermore, S.T. *History of Block Island*. Reproduced and enhanced by the Block Island Committee of Republication. Forge Village, MA: Murray Printing Company, 1961.

Soares, Joseph P. *The 1938 Hurricane Along New England's Coast*. Portsmouth, NH: Arcadia Publishing, 2008.

Other important sources we found useful in covering this subject were several issues of the *Westerly Sun* and the *Providence Journal*. These newspapers covered the *Larchmont* disaster as it unfolded.

INDEX

ABOUT THE AUTHORS

Janice and Joseph Soares were born in Rhode Island, "The Ocean State," and early on, acquired an appreciation and awe of New England's maritime past. Meeting in high school and marrying several years later, they both persued a desire to write and document episodes of New England's past. After graduating high school, Janice went on to receive a bachelor's degree in business administration from Providence College.

Working in finance for over thirty years, Janice has refined her skills in analyzing and writing. With a desire to broaden her writing abilities and her passion for history, she joined with her husband to author her first

Janice Soares, Joseph Soares and grandson Michael Morgan.

book. Joseph, an established author who has written several books based on local history, is pleased to have the opportunity to work on this project along with his wife in documenting the *Larchmont* disaster.